American Byzantium

For Andrew, Nathan, and Judith

Virgil Hancock III

For Marianne

Gregory McNamee

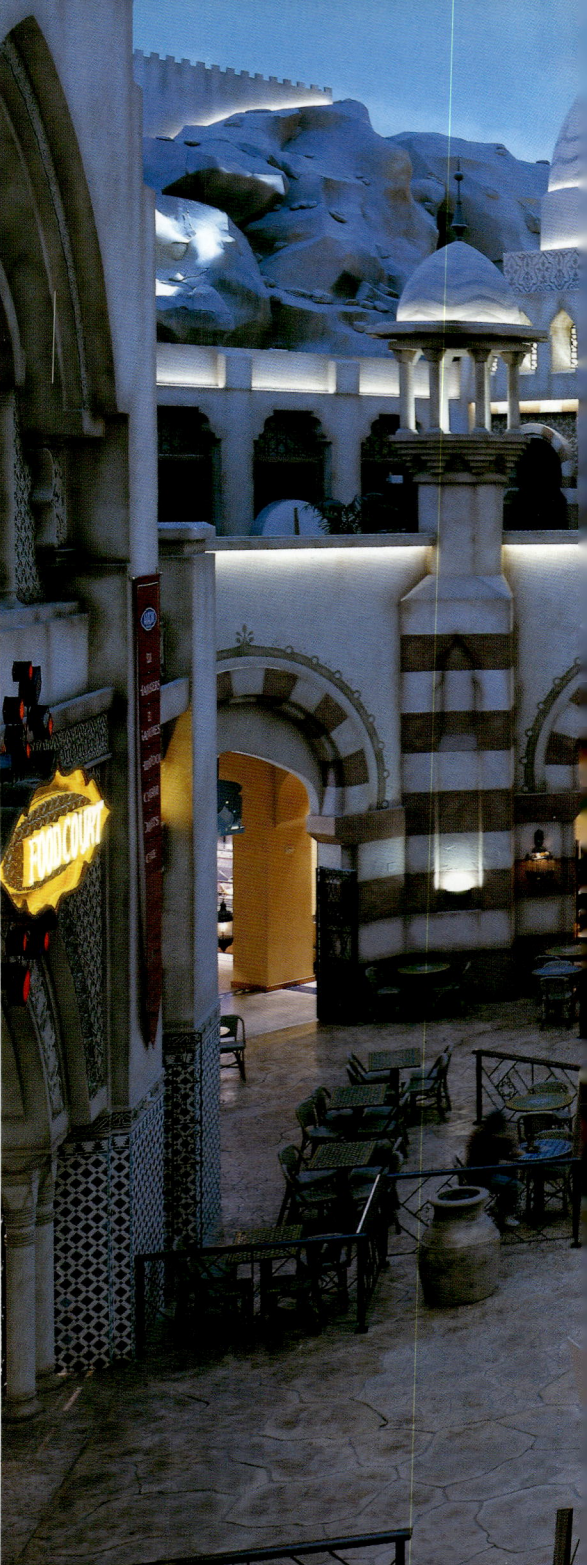

The Lost City, Desert Passage

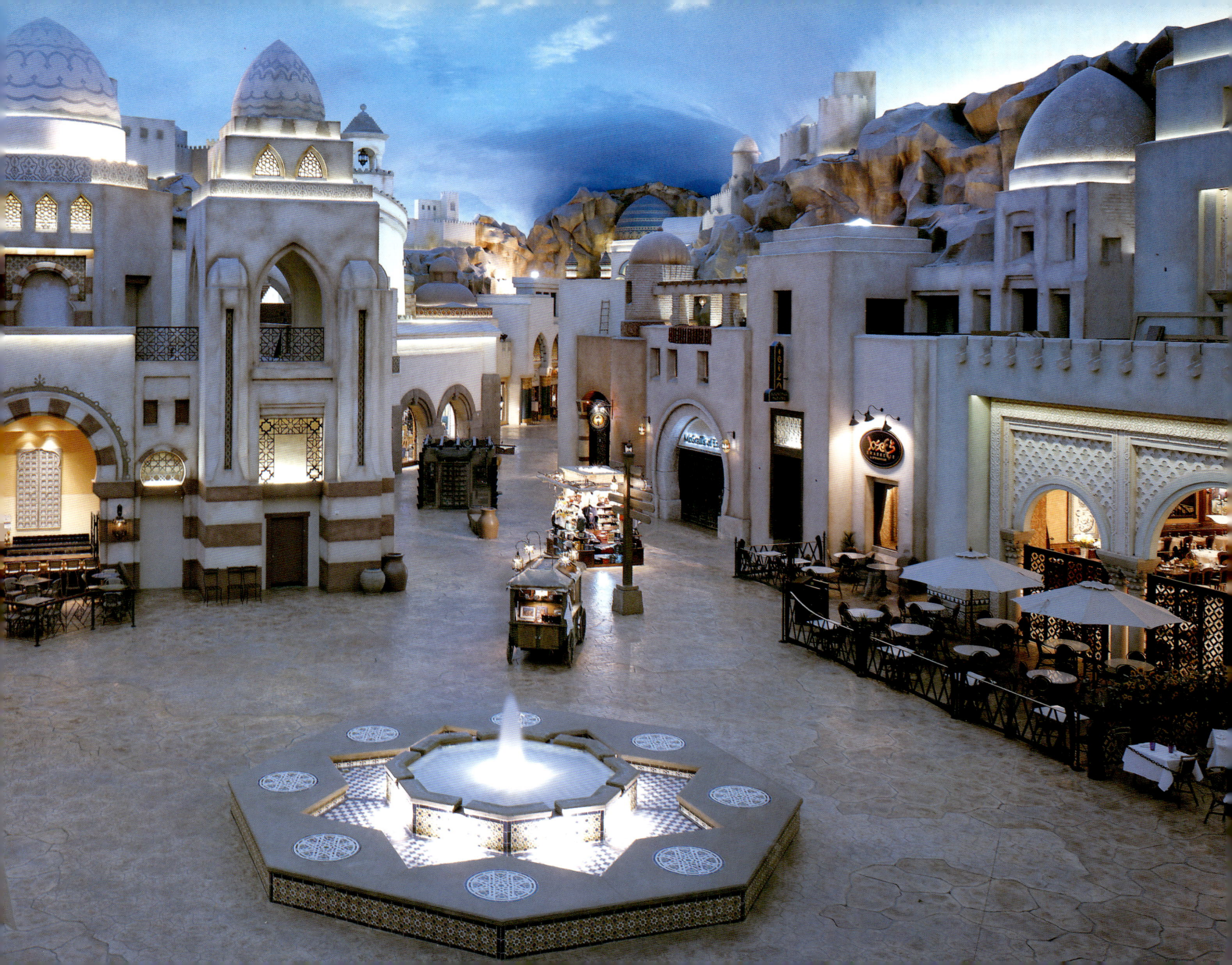

AMERICAN
PHOTOGRAPHS OF LAS VEGAS

BYZANTIUM

PUBLISHED IN COOPERATION WITH THE

UNIVERSITY OF ARIZONA SOUTHWEST CENTER

UNIVERSITY OF NEW MEXICO PRESS

ALBUQUERQUE

BY

VIRGIL HANCOCK III

WITH AN ESSAY BY

GREGORY McNAMEE

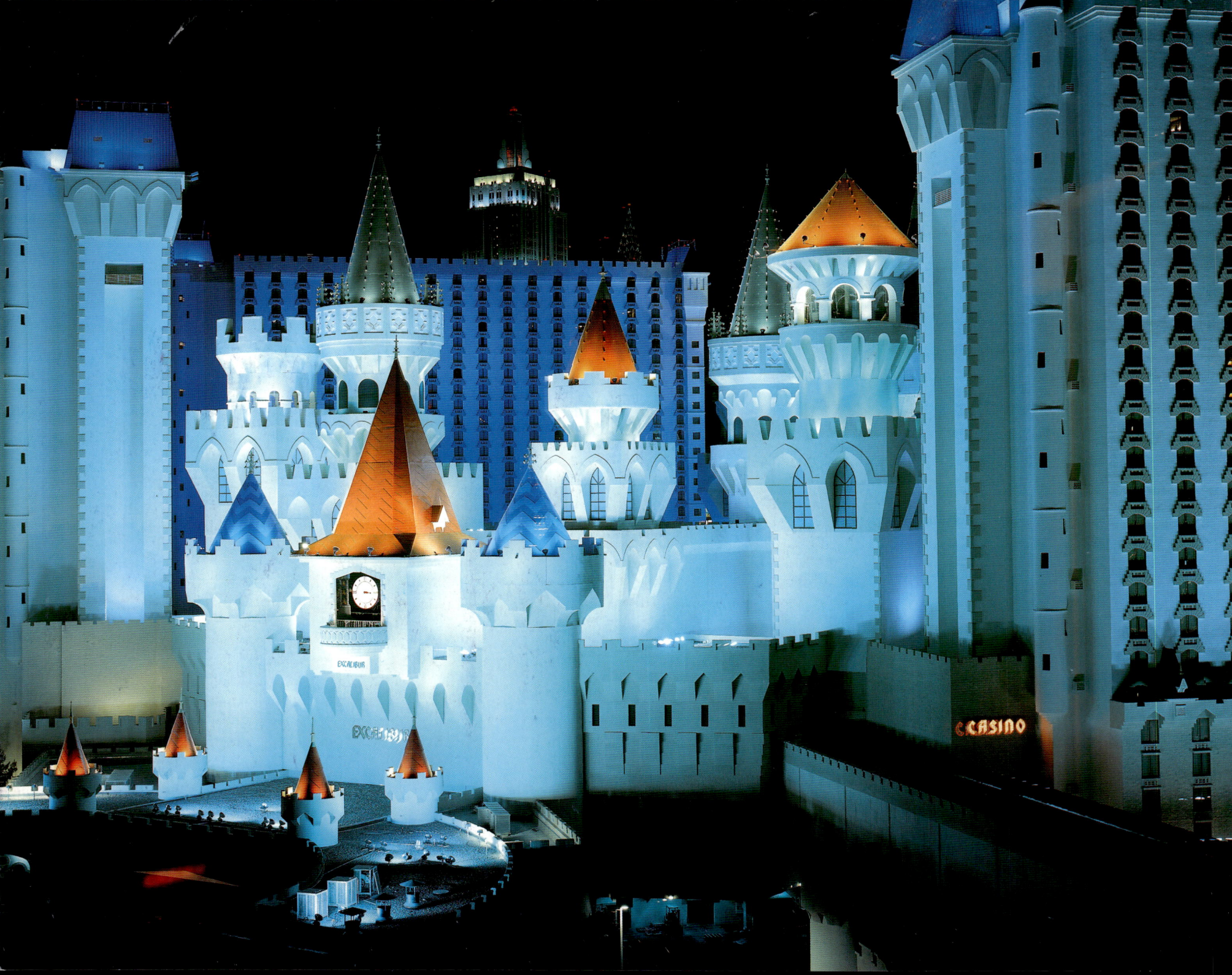

SAILING TO LAS VEGAS

LAS VEGAS AND BYZANTIUM

IN THE 21ST CENTURY

INTRODUCTION BY VIRGIL HANCOCK III

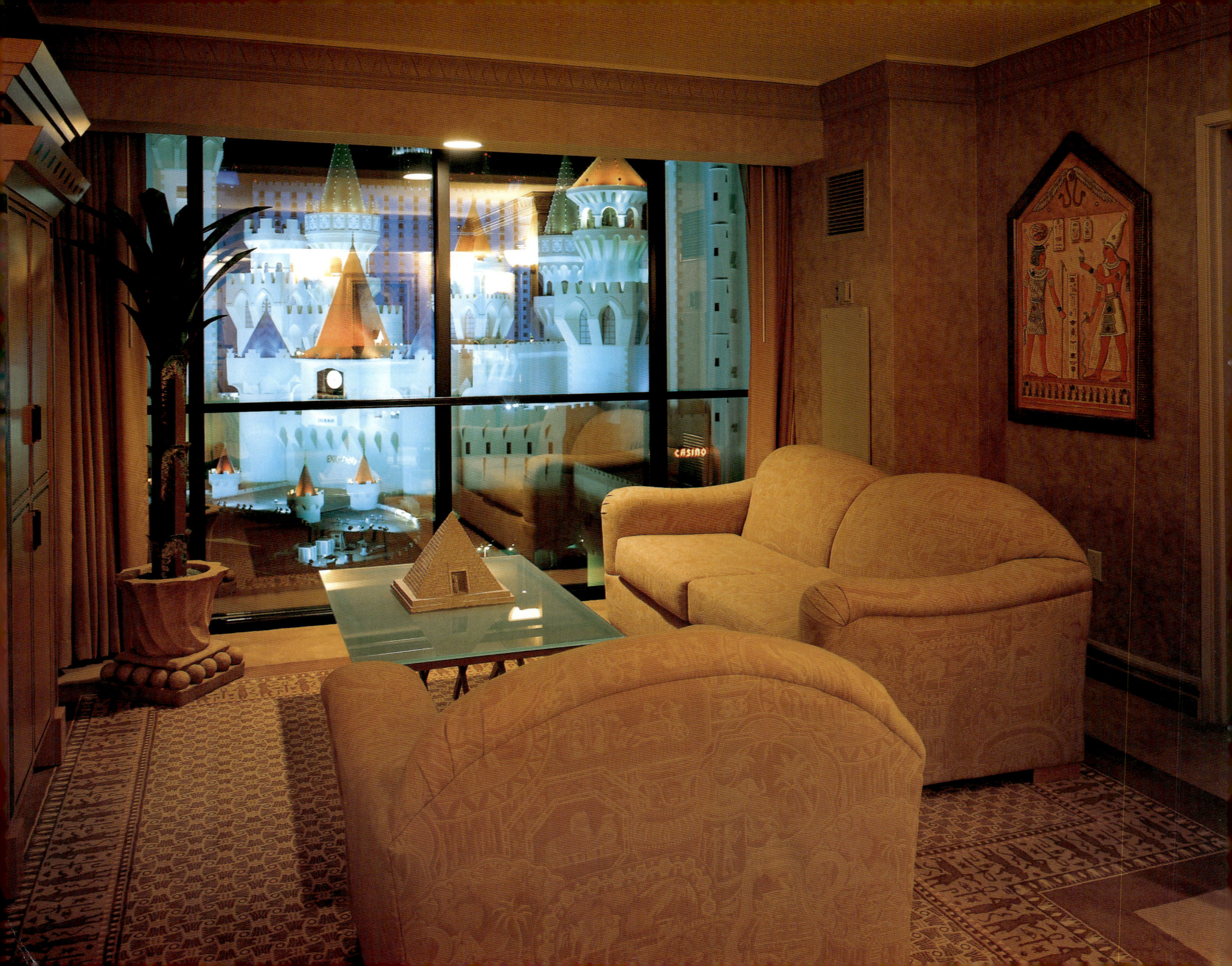

I. In 1453 the armies of the Ottoman Sultan Mohamet II attacked and overran Constantinople killing the last Byzantine Emperor and establishing the reign of Islam in place of Christianity. Yet when Pierre Gilles studied the buildings and ruins of the city nearly one hundred years later he found many of the Christian and Roman monuments preserved. Gilles recorded his findings in one of the most famous travel narratives of the late Middle Ages, *The Antiquities of Constantinople*. Nearly five hundred years later many of these same monuments still remain.

What a strikingly different situation exists in Las Vegas, Nevada, USA. There have been no wars or major political or religious changes over the last hundred years, yet there are very few public buildings or significant ruins from the past in Las Vegas. They have all been leveled to make way for new construction. The only past that the market will preserve is the one that makes money. Thus houses in established neighborhoods might be resold but commercial property if it cannot make money is torn down. Even the grand casinos like the original Flamingo or El Rancho are only preserved in photographs. The only past that makes money in Las Vegas has nothing to do with the history of the city. It is the past of dramatic and heroic places such as the dynastic period in Egypt or Caesar's Rome. Against these fantasy historic backdrops, one visits the city to indulge in the material and spiritual realms of pleasure.

I came to this desert crossroads as a traveler, driving to Las Vegas to visit the sacred sites and monuments of entertainment capitalism. Entertainment capitalism uses whatever theme, concept, commodity, performance, illusion, service, or experience is marketable and places it up for sale. Thus lodging, gambling, watching, playing, golfing, exercising, dining

Room at the Luxor | *Excalibur (previous spread)*

out, dining in, performing, walking, swimming, acting, dancing, drinking, having sex, and all other pleasurable and entertaining activities are available for a price. Las Vegas is the total pleasure market. Everything is for sale.

The market and entertainment have always been intimate partners throughout history. From the trade fairs of antiquity and the Middle Ages to the shopping malls of contemporary America, entertainment has always been part of the experience of consumption. Storytellers, magicians, parades, and circuses were inseparable from the ancient art of buying and selling. The market has evolved over the centuries to its current pinnacle in Las Vegas. Las Vegas is the grand climax of the relationship between entertainment and consumption: capitalism as a giant party! This is Club Utopia.

My education in life, economics, medicine, and religious studies did not prepare me for Las Vegas. The reality of Las Vegas is so intellectually and emotionally intimidating that the first reaction to the place is similar to that confused smugness of an adolescent when encountering something he knows in his heart is way beyond his comprehension. Las Vegas is the most advanced city in the global market. Just as Jesus took the Hebrew religion to a new level, Las Vegas has taken capitalism to a new level. In Las Vegas one can not only glimpse, one can also experience the future of the market.

I traveled the city like most other visitors: by car and by foot. When I walked I took my backpack, which was loaded with my 8 by 10 wood field camera, several lenses, twenty-plus film holders, and tripod (around eighty pounds total). I carried it up and down Las Vegas Boulevard (also known as the Strip), along sidewalks filled with people speaking dozens of languages, in and out of elevators and escalators in casino city-states and museums, searching for the right combination

of signage, symbols, and lights to photograph. There were no relics of dead Christian saints here, but there were numerous shrines to entertainment legends of the past. Whenever I finally decided to set up my camera, I looked so strange under my dark cloth that many tourists took a picture of me. I became a part of the show.

Being in Las Vegas, I felt immersed, like a newly baptized adult, in the river of buying and selling. But it wasn't only objects that were bought and sold. The things that money could not buy were on sale here: feeling, possibility, imagination, fantasy, love, faith, sin, meaning, shame, failure, success, and wealth. I felt that I had been transported into a science fiction version of the Middle Ages. Only instead of Christianity being the dominant religion, the dynamics of the market had replaced it. Other religious, philosophical, and ethical belief systems were slipping into the darkness as did pagan belief systems in medieval Europe.

Walking down the Strip, I remembered that a world did exist outside of this place. A world where the losers exponentially outnumbered the winners, where breaking even after the monthly paycheck was celebrated as being middle class, where the quality of all government services was deteriorating as steadily as milk in a refrigerator in a house with no electricity. Though here, in this 21st century Coney Island, that world did not matter. Like magic, it had vanished.

"Things are not what they seem," as Mick Jagger sang in his song "Sister Morphine." Las Vegas, which initially seems all about money, is also the world center of magic. In many ways money and magic are just two sides of the same coin. According to Elizabeth Butler in her classic 1949 book *Ritual Magic*, "the fundamental aim of all magic is to impose the

human will on nature, on man, or on the supersensual world in order to master them." In the 21st century, the way the human will is imposed on others is through money. What magic was in primitive cultures, money is today: the means to obtain our desires. Money has replaced magic as the way by which people get what they want.

Like the many different forms of money, there are also many different types of magic. Las Vegas is also about the magic of illusion as entertainment and power. It is about material and spiritual alchemy—the transformation of fantasies into reality and the purification of consumption. I wanted to capture the visual and architectural alchemy of this city—this symbol of global entertainment capitalism—in my pictures. That is why I decided to photograph Las Vegas.

II. Why do I call Las Vegas an "American Byzantium"? I see strong parallels between Las Vegas and Byzantium, the trading and cultural capital of the Ancient world. Byzantium was the leading entrepôt of trade, culture, and beliefs between Europe, Asia, and Africa during the first millennium. As a city, Byzantium (founded in 667 B.C.) was characterized by major transformations from its original beginnings through its rebirth under Constantine to Constantinople (around A.D. 330), which was the capital of the eastern Roman Empire, to its later incarnation through Islam (beginning in A.D. 1453) to the capital of the Ottoman empire. Throughout these periods it has been a world city: a commercial, intellectual, and spiritual center.

One of the best accounts from a traveler during the Byzantine period (330 to 1453) of the city of Constantinople is

Star Trek Experience at the Hilton

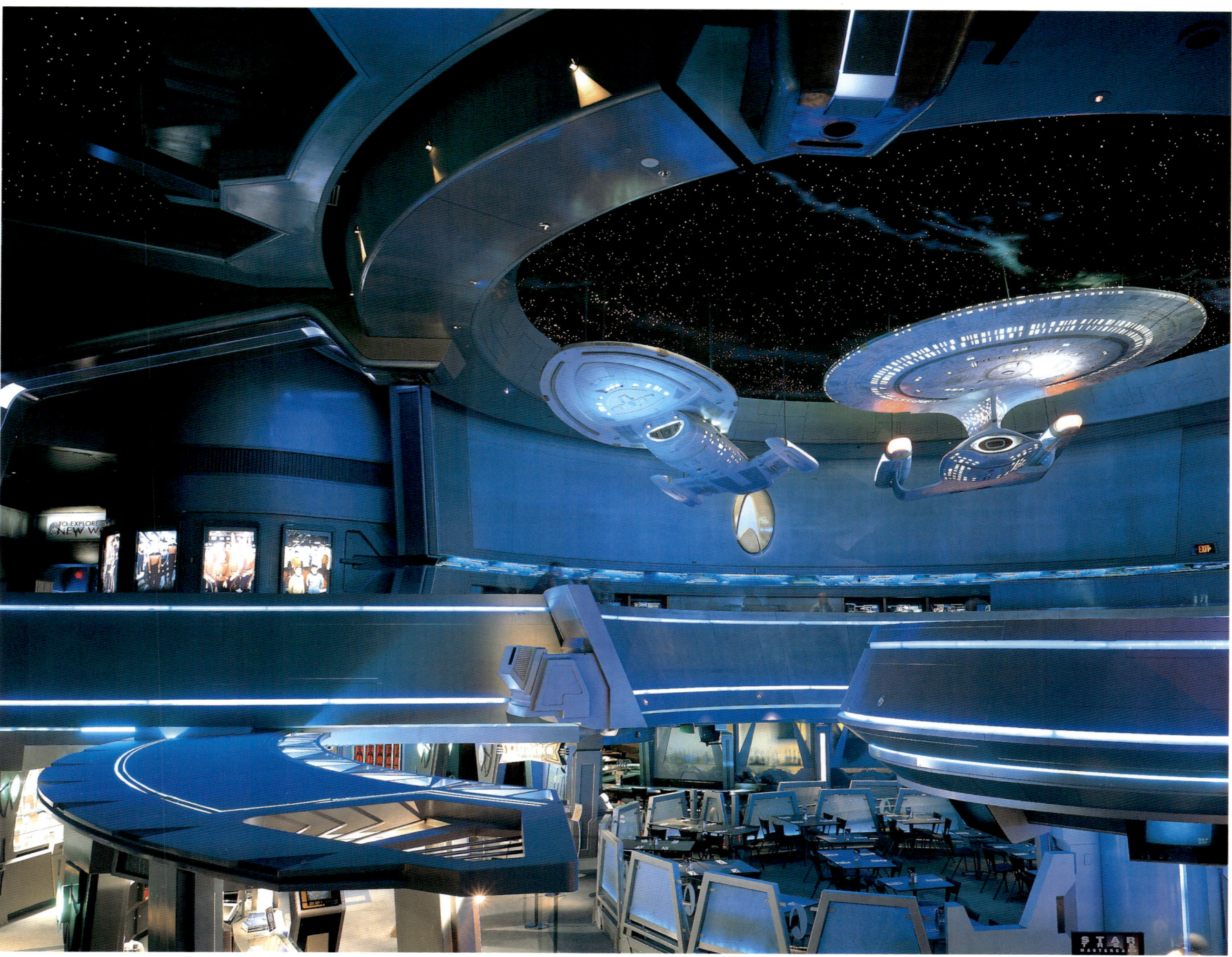

that given by Benjamin of Tudela who journeyed throughout Europe and Asia in the 12th century.

> *Constantinople is a busy city, and merchants come to it from every country by sea or land, and there is none like it in the world except Baghdad, the great city of Islam. . . . Close to the walls of the palace is also a place of amusement belonging to the king, which is called the Hippodrome, and every year on the anniversary of the birth of Jesus the king gives a great entertainment there. And in that place men from all the races of the world come before the king and queen with jugglery and without jugglery, and they introduce lions, leopards, bears and wild asses, and they engage them in combat with one another; and the same thing is done with birds. No entertainment like this is to be found in any other land. . . . Wealth like that of Constantinople is not to be found in the whole world. Here also are men learned in all books of the Greeks, and they eat and drink, every man under his vine and his fig-tree.*

Constantinople was also the spiritual center of Greek Orthodox Christianity. The city specialized in gathering relics of the Passion, which included at least three pieces of the True Cross (the cross on which Jesus was crucified), the pillar on which Jesus was scourged, the crown of thorns, the Sacred Lance that pierced his side, and the sponge used to wipe his brow. Other relics included the Virgin's robe, girdle, and shroud as well as the head of John the Baptist. The empire of Byzantium had about 3,600 relics of 476 Greek saints located in 427 churches, monasteries, and other institutions. The bodies of the three magi, who visited Jesus at his birth, were said to have been brought by the Empress Helena from India to Constantinople and later transferred to Milan and then to Cologne.

Las Vegas has become a world crossroads of consumer entertainment cultures—ranging from restaurants, roller coasters, and rock and roll to world heavyweight boxing championships and international magic acts at the beginning of the third millennium. Like Byzantium, Las Vegas has also been reinventing itself, though at a much more rapid pace, with its near complete transformation taking place every ten years. Byzantium was transformed by politics, war, and religion. Las Vegas was transformed by new regimes of capital: from mob monies to teamster pension funds to the personal wealth of Howard Hughes to global corporations. Unlike Byzantium, Las Vegas has kept its original name. Yet the city has radically changed during each new infusion of capital. People talk of the "old Las Vegas," referring to the mob period of the 1950s and 1960s as if they were referring to another city. The contemporary world of corporate Las Vegas has witnessed tremendous city growth, changes in the city's financial and business structure, as well as the rebirth of the city's skyline.

Like ancient Byzantium, Las Vegas is also a place of extreme contradictions and complexities. Along Las Vegas Boulevard, giant casino city-states compete for tourists by adapting mythic and fantasy facades to draw customers into multilayered experiential entertainment shopping malls. From this corporate center of casino capitalism the city radiates outward: a typical western city of housing developments, shopping centers, public schools, churches, and small businesses exponentially expanding toward the desert valley edges.

Within this gridlock of roads and developments is the strongest union town in America: the "last Detroit" as Hal Rothman, a historian and contemporary commentator at the University of Las Vegas, Nevada, puts it. Here the struggles

between labor and capital play out in front of the non-unionized casinos on a daily basis. The confrontations during the last few decades have included some of the most celebrated strikes in recent U.S. history. Las Vegas is also a city of numerous organized religions and strong communities emphasizing traditional midwestern values. It is a city filled with new immigrants from throughout the United States as well as from around the world.

Las Vegas shows us what it means to live in a total market economy. The impact of the market begins before birth and ends after death. In between these two events is a long history of endless consumption and property rights. Things, choices, health, and lifestyles are determined by the amount of money one inherits, accumulates, earns, or is given by government, charities, or strangers on the street. Our identity becomes what we purchase: from ranches outside of Aspen to rubbing alcohol. The predominance of the market has affected us so thoroughly that we neither see it clearly nor understand its history. Historians who have tried to understand the evolution of the market—such as Fernand Braudel or Alfred Chandler—are only known to specialists. Like medieval Christians, the duty of the public is not to try to question the model. Thus the fact of the extreme inequality between winners and losers—which is the essence of a capitalist market—is a reality that is supposed to be just accepted.

Magic is a very underestimated aspect of Las Vegas. Magic exists throughout the city on the primitive personal level of gamblers rubbing their hands together before pulling a slot machine lever or rolling the dice. The professional magic performances—which sell out night after night in the giant casino city-states on the Strip—are the world's most sophisticated

examples of illusion—next to the wealth fantasies of the city's tourists. There are probably more magicians per city block in Las Vegas than in any other city in the world. Las Vegas is to the magician what the Vatican is to the Catholic.

Along with being filled with magic, Las Vegas is also a very spiritual city. Spiritual in this case is used within the framework of the Gnostic or Platonic philosophies. Gnosis means knowledge. The Kabbalah, Gnostic, Hermetic, and Neo-Platonic traditions of Europe in the late Middle Ages and the Renaissance were belief systems that focused on obtaining the knowledge and experience of God by working one's way through the distractions of the material world. They were systems of spiritual education: understanding the relationship between God and matter. Las Vegas can be studied as the materialized spirit of capitalism: the word made flesh. Capitalism is three-dimensional here and can be touched as easily as the handle of a slot machine.

The city is a Neo-Platonic feast filled with levels of meaning and invisible connections. The words used in advertising throughout the city are an example. The neon metropolis is replete with powerful words. These words tell you what to do and what to believe. If you follow them you could spend large amounts of money and end up living in very organized neighborhoods run by Stalinist homeowner associations. In Las Vegas these words are on billboards, buildings, and street signs. They are written in black lettering and in neon. Las Vegas is an occult, alchemical, and iconic destination filled with allegories, symbols, and metaphors that simply wait to be consumed on the public streets.

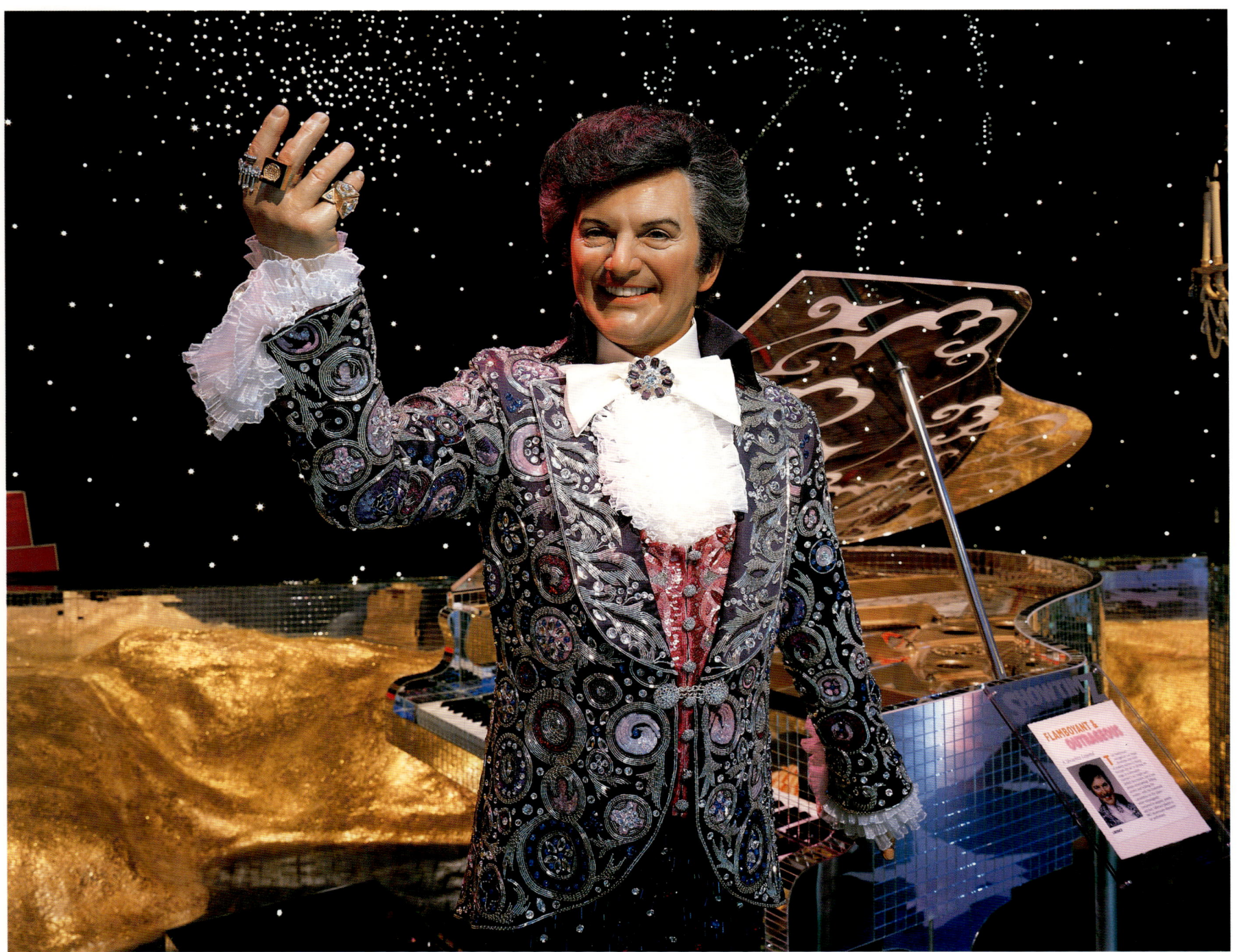

III. How does the magic become personal in Las Vegas? A book written nearly two thousand years ago can help answer this question. The book is *The Golden Ass of Apuleius*. It is a story about Lucius, a Greek nobleman, who takes a business trip to a town called Hypata. Told through a series of stories, our narrator observes an intense magical world of witches, sorcerers, and jealous gods all driven by desire and lust into dangerous realms of pleasure and entertainment. Our hero, through magic, is transformed into a jackass and experiences the majority of the book as this animal, and is both an object of ridicule and a vehicle for work used by his various unfortunate owners. At the end of the narrative he is to be part of an entertainment extravaganza taking place in a large amphitheater in front of enthusiastic crowds: he is the main attraction of a sex show with a woman condemned to death as his partner. He miraculously escapes from his cage below the amphitheater, gallops down to the beach with a night moon rising, and appeals to Isis—earth goddess—for salvation. She grants his wish and the following day during a religious entertainment spectacle he is transformed back into a man. Not only does he become an important initiate in the cult of Isis and Osiris but he also becomes successful in the market world of Rome as a famous attorney.

It is a strange book to read at the beginning of the 21st century. The rules of life appear so different from those of our own age until one steps back to see how the power of desire, the lust for more, transforms everything the narrator touches and that we touch. If one descends into the sensual and seductive chaos of life without discipline or a strong belief system, one is at risk of personal destruction. Las Vegas is a place where all addictions—sex, gambling, money, shopping,

Liberace, Madame Tussaud's Las Vegas

drink, drugs, pleasure, eating, power—have no limits. The only way to curb the illusions they offer is through the power of a disciplined belief system. In the case of Lucius it is the cult of Isis and Osiris, in our case it is contemporary mystery cults (such as modern religions, 12 step programs or philosophical belief systems) or the unexciting discipline of moderation. In the end Lucius obtains a successful belief system and an occupation that secures him a place in the market. This combination is not an unreasonable compromise. It is how many of us choose to defend ourselves from the unlimited addictive magic of capitalism and Las Vegas.

IV. Like all pre- and post-scientific worlds, Las Vegas is also about stories: narratives of personal experiences. These stories range from feminist political icons like Eleanor Roosevelt, who became fascinated with a rigged slot machine in the El Rancho casino, to sex goddesses like Jayne Mansfield, who wrote a letter to a Las Vegas columnist expressing how much she wanted to return to the city just before she drove down to New Orleans and was decapitated in a car accident. The stories of famous performers and entertainers are valued in this city like the narratives of Catholic saints or the myths of the Greek gods and goddesses of Mount Olympus.

My experiences confirmed these other aspects of this magical world. I was setting up my tripod near midnight to photograph the Mormon Temple just outside the gates in the eastern suburbs above the city. My tripod was in place, the

Aladdin

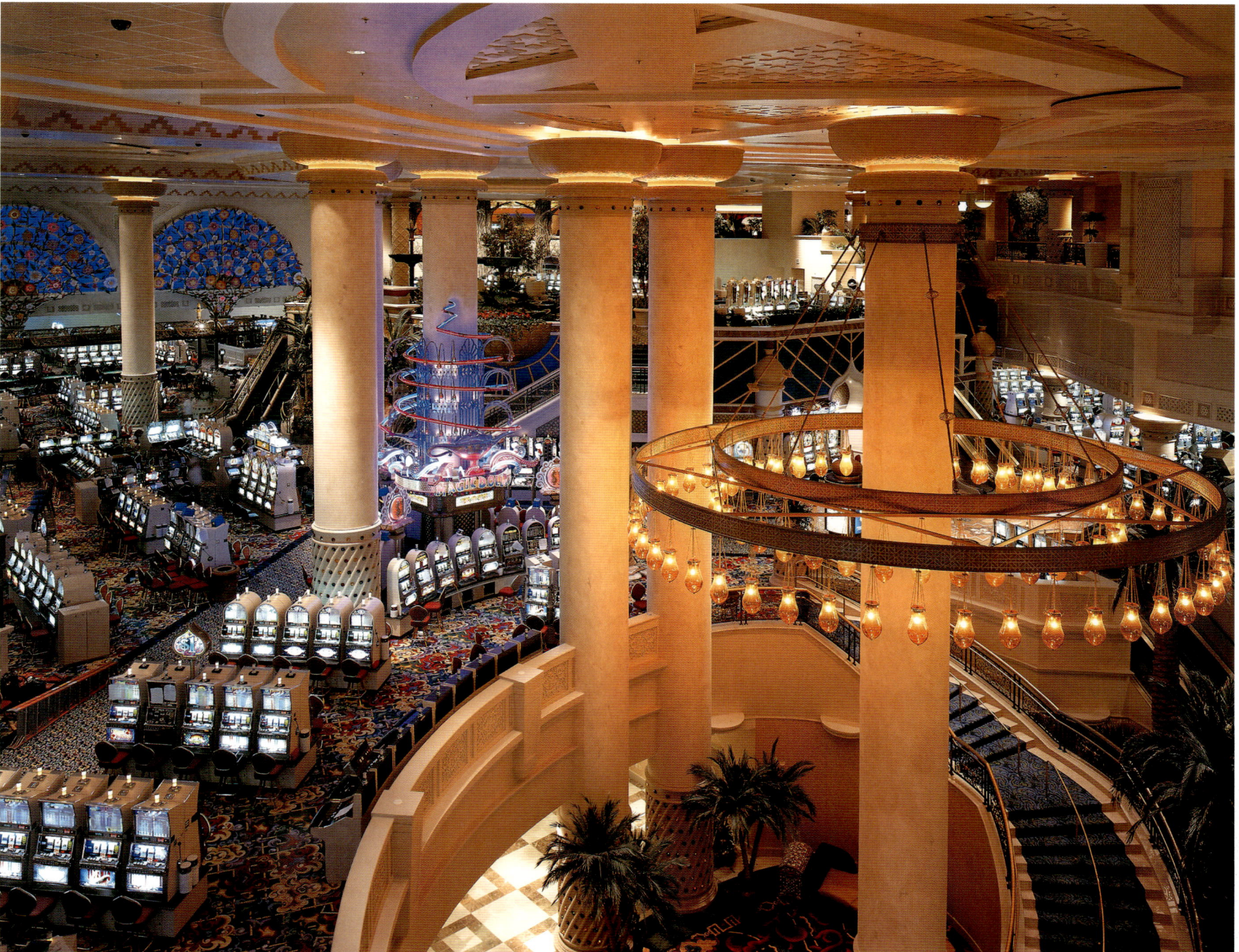

wood field camera set up, the wide angle lens in place, and the bellows appropriately extended for focus. Beneath the dark cloth the image was in focus on the ground glass. A young woman walked up to me and asked what I was doing. I told her. She mentioned to me that she was a neurosurgeon. Having a medical background myself, I asked her what medical school she had gone to. She replied she hadn't been to medical school yet. In fact she hadn't started undergraduate school. She was taking a couple of classes in a community college and raising two children as a single mom. Yet she said without a hint of humor or embarrassment that she was a neurosurgeon. Why not! After all this is Las Vegas!

Being here but being somebody else, like Lucius in *The Golden Ass*, is an essential part of the magic of the city. My best introduction to this was in the Hall of Fame of Magic and Movies: one of the few non-corporate tourist attractions of the Strip. Valentine Vox designed and operated this museum, documenting a history of magicians and ventriloquists. He also wrote a book on the history of ventriloquism and sponsored a yearly ventriloquist convention that he allowed me to photograph. Ventriloquism is a very ancient component of the history of magic. It has intrigued people since biblical times. It is always raised as part of the question to understand whether the Witch of Endor really conjured the ghost of Samuel for Saul to see or whether it was just her early contribution to the ancient art of ventriloquism. Ventriloquism is the art of illusion. An inanimate object comes alive and speaks with a human voice.

Mardi Gras, another religious festival with magical overtones, is a year-round theme in Las Vegas. This is especially the case in the large casino Rio. Throughout the late afternoon and night a "Carnival in the Sky" takes place with floats carrying

masked performers (to the accompaniment of music), who encircle the casino main floor suspended above the gamblers and tourists. The Rio changed ownership while I was working on the project. The earlier ownership allowed me to photograph the show. The new owners would not allow me to use the image in the book. The image was stunning—lights from the sky-floats trailing through the dark casino sky and the illuminated stage and slot machines below. In the foreground was a row of slot machines called Voodoo Dollars.

Other corporations and casinos did allow me to both take and use the images in the book: Main Street Station; Star Trek Experience; Red Square and the Rum Jungle; The Aladdin; Circus, Circus; The Luxor; Desert Passage; Paris; Las Vegas; The Venetian; The Forum Shops at Caesars; Madame Tussaud's; Guinness Book of World Records; and The Attic. Their decisions to allow me to use the images expressed their pride in their product. The corporate architectural and entertainment products of Las Vegas are extremely creative endeavors. Capitalism's imaginative spirit is pushed to its limits here.

V. The sites I chose to photograph in Las Vegas fell into four categories: night images of the Strip; day images of signage and buildings throughout Clark County; interior images of casinos, stores, museums, and malls; and people. I chose signage that represented themes I mentioned earlier: Live the Life, Love the Price; Organized Living Get into It; No Exit; Your Future Starts Here; Memories; Club Utopia; House of the Lord; Celebrity Center; Global Power for America, and so forth. But I

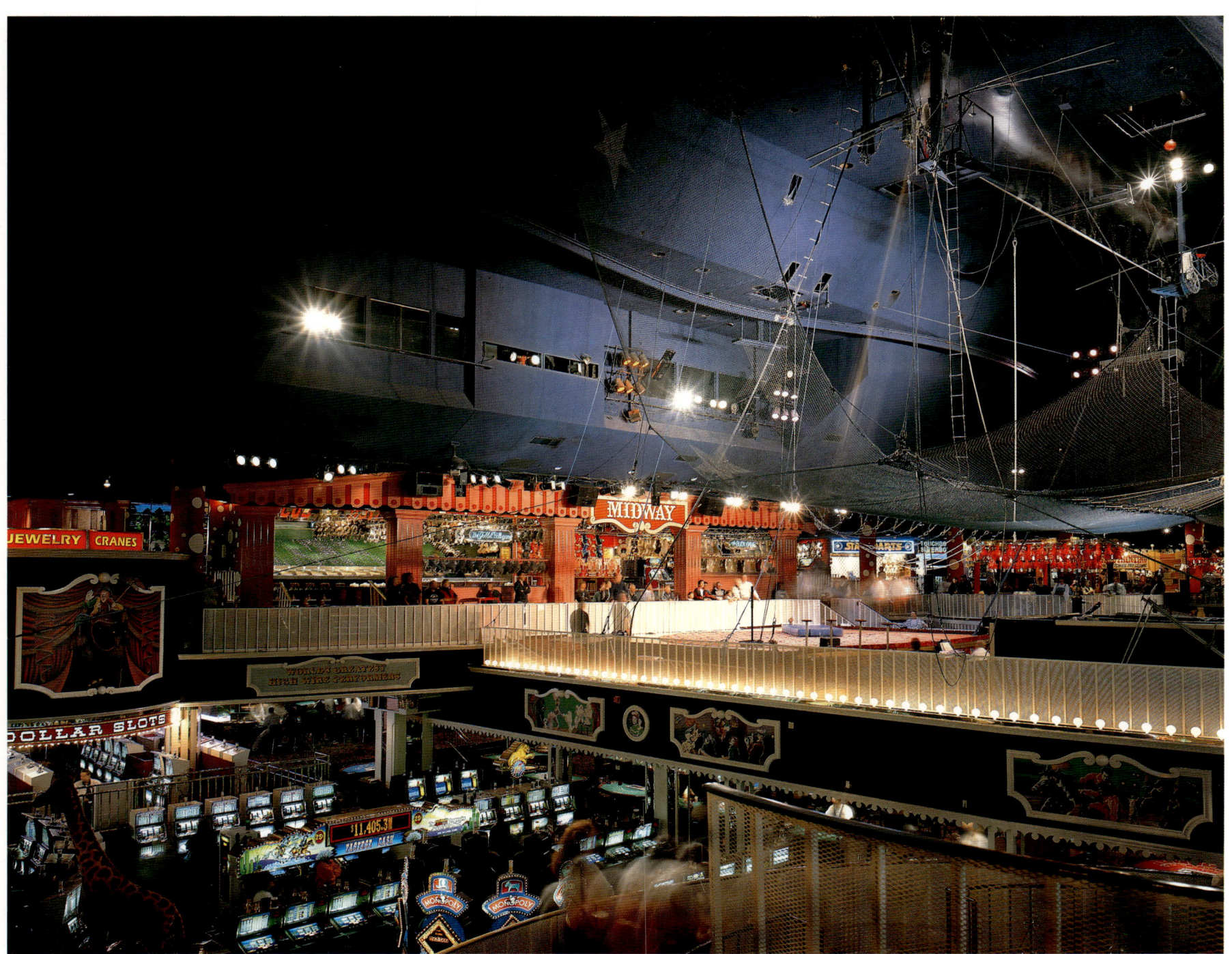

also selected images that showed the market itself: the sublime interior landscapes of The Forum Shops at Caesars; the four-layered Aladdin on grand opening day; the interior of Paris and the Venetian; and the exteriors of Drive Thru Pawn and Drive Thru Weddings. The spectacle of Las Vegas and its appropriation of myths—both its own and others—are represented in such images as The Effiel Tower, The Luxor, and The Excalibur as well as the two images dedicated to Bugsy Siegel, the godfather of Las Vegas.

I paid tribute to the essential neon-lights-on-the-hood-of-a-car image included in every Las Vegas film in my shot of the Riviera at night in which its splash of lights is reflected on over a dozen automobiles. That main magician of contemporary culture—the celebrity—is well represented in the photographs of Marilyn Monroe, Liberace, and others in Madame Tussaud's Wax Museum. In Red Square in Mandalay Bay I found a metaphor for 20th-century Russia: a beautiful workers' mural behind the restaurant bar with a headless statue of Lenin in front of the restaurant and Lenin's head preserved in the vodka locker waiting to be pulled out and used like any old animal part needed for a magical spell.

The five people shots deserve special mention. I was not planning on having any shots of people in the book initially. The 8 by 10 format does not easily allow outside portraits or action shots. But toward the end of the project I realized I needed to show the people of Las Vegas: people surviving in the market; people selling themselves in the market; people consuming and enjoying the market. There is also, of course, a non-tourist and more moderate market world in Las Vegas. One where people do not spend their last quarter on a slot machine but are saving for a nicer apartment. Ruben and

Circus Circus's Circus

Delilah Maldonado wanted to be photographed at their favorite spot in Sumerlin. There is the world of Keith Smith who just relocated to Las Vegas for a better job opportunity with his company. (Later, like many other city inhabitants, he discovered that his new house had been a home to an earlier Las Vegas celebrity, which explained all the mirrors in the living room and den.) Hal Rothman came to the city as a history professor and developed an edgy push/pull love for the place. Mark Zartarian is a union organizer, professional photographer, and world-class mountain climber.

My favorite picture of the collection is the group shot of the Ventriloquist Convention of 1999. Every year the group shot of the attendees is taken just before the convention closes. The professional photographer generally stands above the crowd on a hotel balcony. I set up at the same time in front of the crowd, extending my tripod to its full height of about seven feet. I was on a ladder and took five images. The one included here is my favorite. It shows all the individual ventriloquists and their dummies. Throughout the convention they have had the chance to perform their magic on stage for the entertainment of themselves and others. They have had a good time. In the midst of this overwhelming, disorienting, and magical city—this symbol of the global market—these magicians have carved out a niche and are enjoying it. ♣

Fun City, Las Vegas Boulevard | *Ventriloquist convention, 1999 (following spread)*

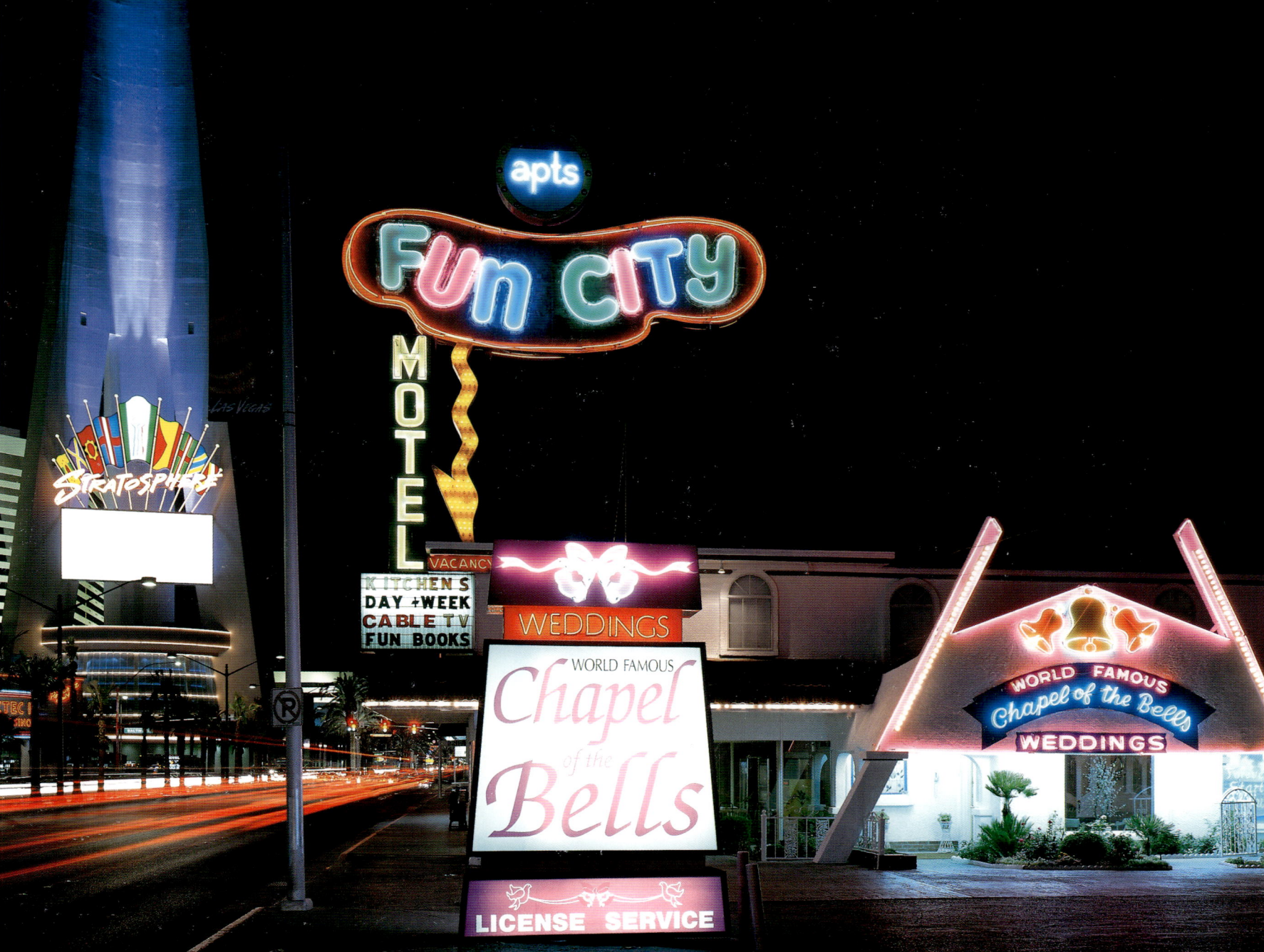

AMERICAN BYZANTIUM

22

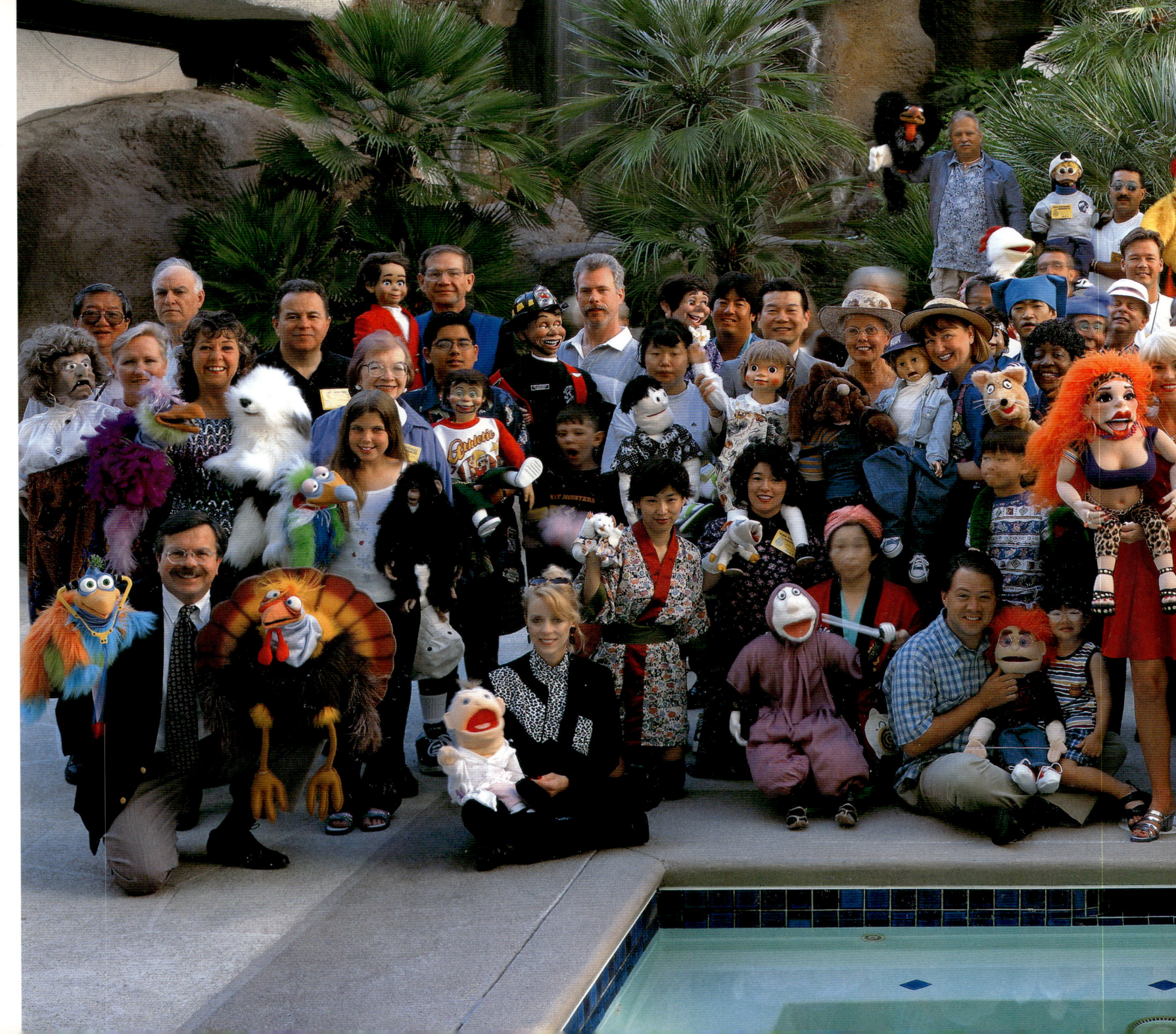

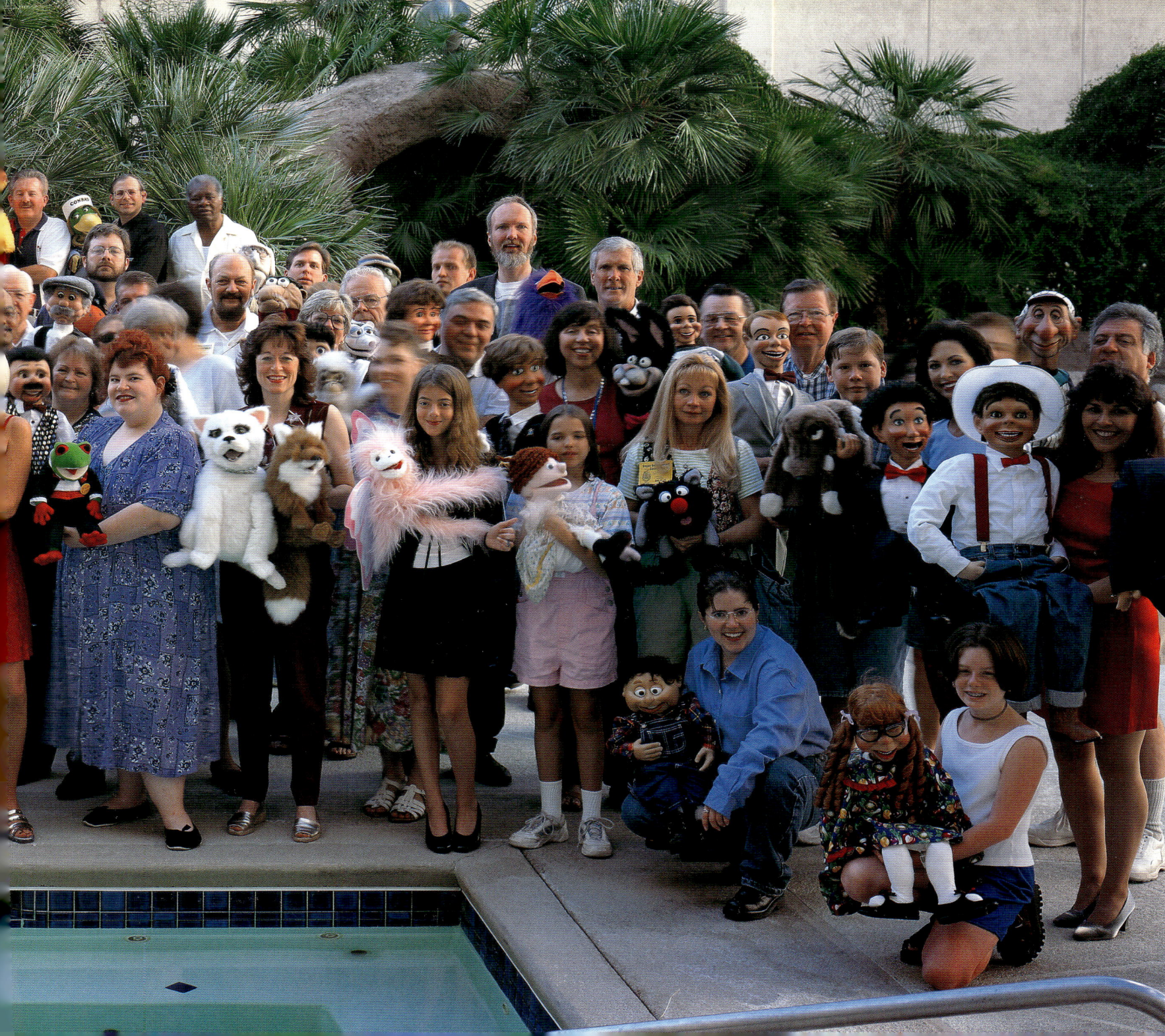

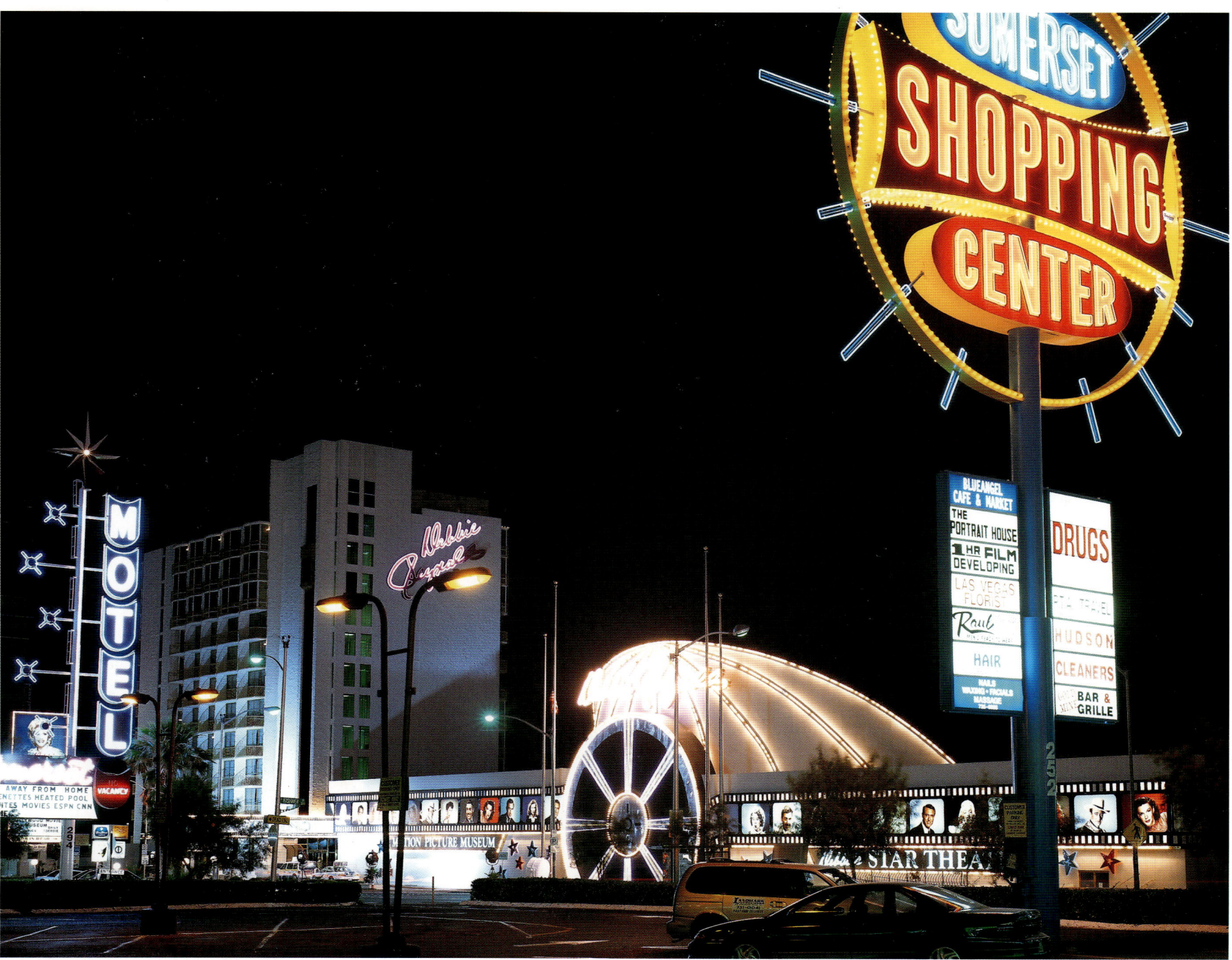

Shopping Center

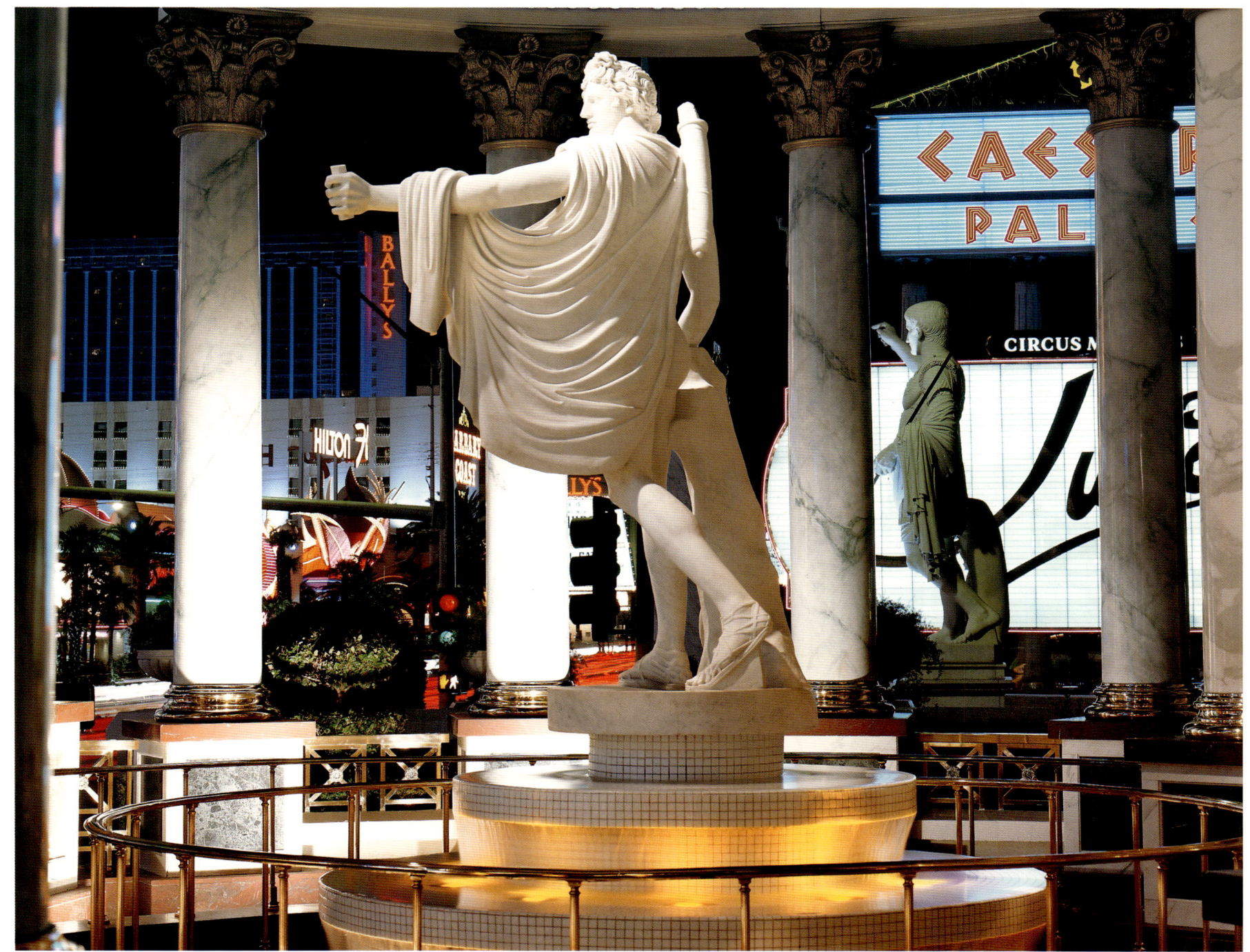

Roman Statue, Stop Light, Las Vegas Boulevard

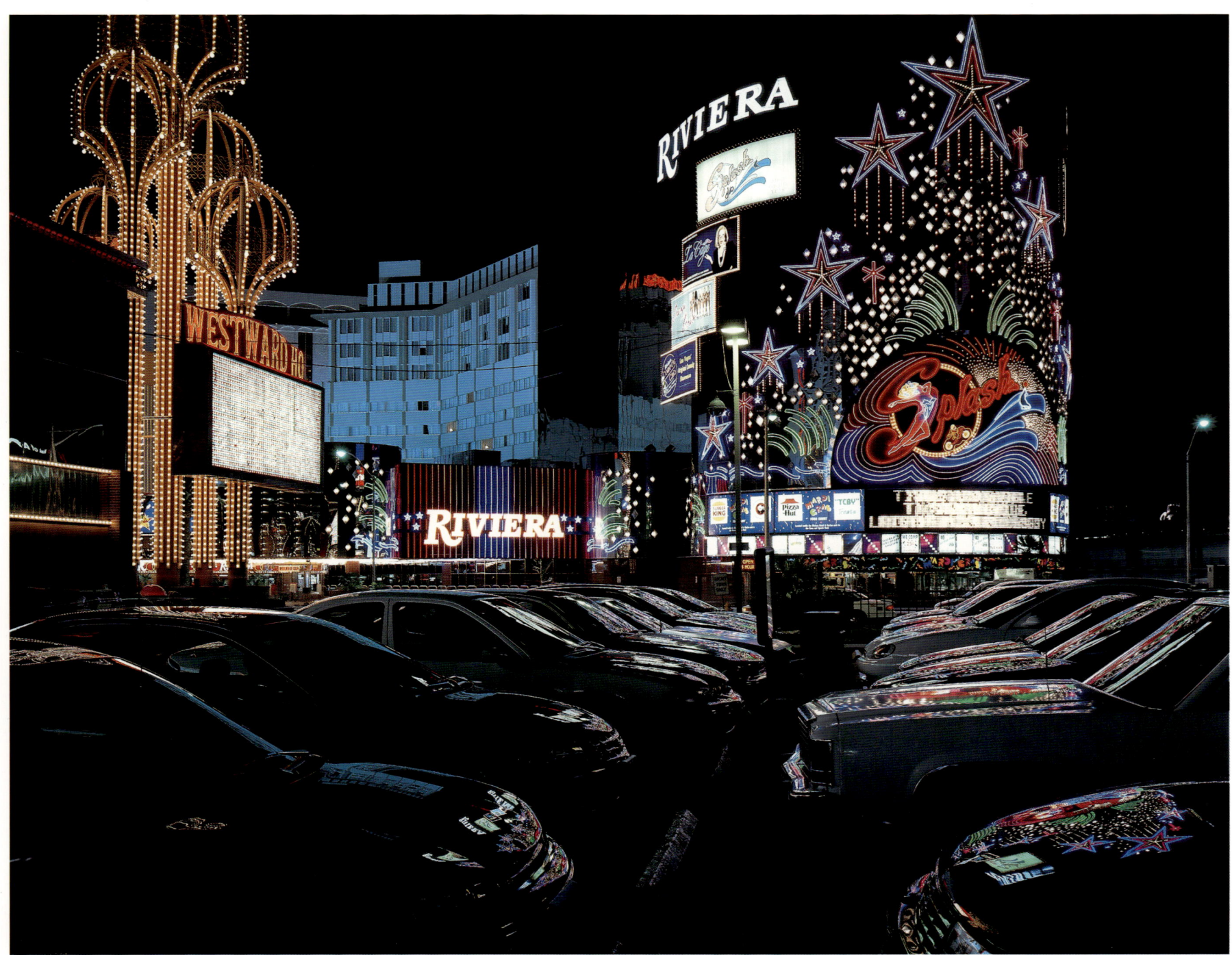

Riviera, car hood reflections

Rum Jungle, Mandalay Bay

Drive-Up Wedding Window

Drive-Thru Pawn | Luxor Pyramid among ruins (following spread)

AMERICAN BYZANTIUM

30

AMERICAN BYZANTIUM

31

AMERICAN BYZANTIUM

BY GREGORY McNAMEE

IT BEGINS WITH THE WIND.

The wind blows always, incessantly, in Las Vegas, apocalyptic and unsettling, stirring up the detritus of an unfinished desert civilization: cigarette butts, tumbleweeds, thirty-gallon trash bags, show passes, throwaway flyers for massage parlors and in-room escorts, and, not so long ago, quantities of radioactive fallout. The wind comes howling down across the valley from 11,919-foot-tall Charleston Peak, sweeping dust and debris before it, announcing its authority in a howling blast. There is no escaping it. Wherever you go in Las Vegas you hear its fierce undertone, a roar punctuating the demented whoop-whoop of slot machines paying off their load of coin, the ever-present police sirens, the babel of languages that careens like shrapnel off retaining walls and handrails: Japanese, Mandarin, Arabic, German, Spanish, Middle American.

The heat of Las Vegas fuels the standup comedians' jokes: It was 123 degrees when I flew in to Vegas this morning. I would have gone to the sun, but all the flights were booked. That heat is always worth remarking on, save during a few clement weeks in winter. But the wind is the true defining feature of this place, and wind leaves no monuments.

Instead, it tears them down. As does a legion of workers, now busily erecting and dismantling and rebuilding and tearing down one monument after another in the windy city of Las Vegas, constructing and deconstructing the future ruins of Late Republican civilization, among which the wind will one day play.

♠ ♠ ♠

Las Vegas Room, Madame Tussaud's Las Vegas ™ The Estate of Marilyn Monroe licensed by CMG Worldwide Inc., Indpls., IN www.MarilynMonroe.com
New York, New York (previous spread)

Where the wind rules there was once also water, generous springs of bubbling water that nourished the tallgrasses for which Las Vegas—"the meadows," in Spanish—earned its name. Those springs, most of them now disappeared, flowed into streams. Those streams flowed southward into a muddy river that once reached the sea, and thence the ocean. Had they had their sources just fifteen or so miles north, those streams, like all others in the Great Basin, would have disappeared into the alkali pans of the inland desert.

Those free-flowing waters were a rarity in the arid Southwest, and they were recognized as such. In antiquity, local Paiute medicine people maintain, the meadows offered a natural gathering place, a ceremonial site where powwows and trading fairs were held. (Those gatherings have recently been re-created in the form of the Paiute Snow Mountain powwow.) John Charles Frémont, the Western explorer, found the area to be full of Indians of various tribes when he stopped on May 3, 1844, and wrote of the place, "After a day's journey of 18 miles, in a northeasterly direction, we encamped in the midst of another very large basin, at a camping ground called las vegas—a term which the Spanish use to signify fertile or marshy plains, in contradiction to llanos, which they apply to dry and sterile plains."

Those fertile plains drew later visitors, later settlers. From 1855 to 1857, a colony of Mormon ranchers began a cattle operation at Las Vegas, which ended after the Mormon church dismantled many of its communitarian enterprises and settlements. Mormons later returned to the area, having remade their religion into a more perfectly capitalist concern, and they thrived quietly. In 1905, the Mormons and a handful of other inhabitants gathered at what is now the intersection of

downtown's Main and Fremont streets, near the recently completed railroad depot and the first casinos. Those residents were on hand to participate in the first Las Vegas Land Auction, the event that, at least in local history, marks the founding of Las Vegas as a city, just as endless real-estate transactions define it today.

Las Vegas grew slowly at first, a supply and watering station for trains and automobiles crossing the great desert from Los Angeles to Salt Lake City. Its lifeline became the Los Angeles Highway, also known as the Arrowhead Trail, the road Hunter Thompson would so fatefully follow from the bat-haunted confines of the Mojave.

Another lifeline, as literal as the first, became Hoover Dam, built during the Depression as one of America's greatest public-works projects. Las Vegas benefited, then as now, from the water the huge dam brought to it. It benefited just as much from the army of dambuilders who came to the small town each weekend, lured by the handful of casinos and brothels. (A few of those establishments still exist, tucked away among the technological splendors of what is now called the Fremont Street Experience, a dazzling light show for the tourist market, its soundtrack a set of gambling-related tunes like "Viva Las Vegas" and "Luck, Be a Lady.") The dambuilders were followed by World War II-era defense workers, soldiers, and airmen, many of whom liked the spacious desert and stayed after victory was declared in Europe and the Pacific. Their lot was easier with the advent of consumer air conditioning, which made those 100-plus-degree days survivable, made Las Vegas and the rest of the American West habitable.

Legal gambling and tolerated if not strictly legal prostitution were still mainstays in the little Mormon crossroads, and

with a postwar boom fueling the sub rosa economy, organized crime came to Las Vegas in the persons of Benjamin Siegel, Meyer Lansky, Gus Greenbaum, and other refugees from the east coast. It has been said that these men and their colleagues were the true architects of Las Vegas, but I prefer to think that they simply rode an already rising wave, and in any event their contributions to the city, good and bad, are far smaller than has been supposed. Much more important to Las Vegas history are largely unsung figures like Wilbur Clark, the owner of the old Desert Inn, who operated pirate gambling ships off the coast of California until, tired of having to outrun the Coast Guard, he realized one day that he could just as easily lure Angelenos into the desert for their recreation, and at smaller inconvenience to himself.

It was Clark's great dream that the federal government retire its wartime debts by holding a national lottery, to be administered by none other than himself. He was prescient: two dozen states and countless Indian nations now hold lotteries of the kind Clark proposed, recapitulating old history—for the Jamestown Colony was financed by a London lottery until 1621, when the king deemed widespread gambling "an inconvenience, to the hinderance of multitudes of Our Subjects" and banned it.

The real tutelary spirit of the historic Las Vegas is an even more shadowy figure, a man who first realized the power attendant in merging as he did the worlds of business, government, and entertainment, and who thereby helped create the vast collective *panem et circenses* machine of our time. He is the manufacturer and sometime moviemaker Howard Hughes, who moved to Las Vegas for a time in the 1950s and who settled there permanently on Thanksgiving Eve 1966, in the

Clown on Las Vegas Boulevard

Club Utopia

Stained Glass Window, Main Street Station

penthouse of the Desert Inn. He did not last long in the city; on Thanksgiving Eve 1970 he moved away again, by now a frightened paranoiac whose local investments—especially the soon-to-be-bankrupt Landmark Casino—had in most cases ended in failure.

When Hughes first moved to Las Vegas in the late 1950s, he largely disappeared from public view after having for years fueled the newspapers with reports of his amorous and financial exploits, from Jane Russell to the Spruce Goose. And when he did, he created a small media industry: Hughes-sighting. Gossip columns, news magazines, and even the normally staid *Wall Street Journal* were filled, from issue to issue, with news of unconfirmed surfacings, speculations on why the curious billionaire had quietly been buying out little companies, rumors of his having died in a plane crash on the Orinoco or the Zambezi. And Hughes himself, who once craved public attention, knowingly fueled the media's infatuation, never coming out into the open to speak for himself, alternately raging and rejoicing at the image the press had given him precisely because he would not.

His reclusiveness did not extend, however, to public affairs. From his Desert Inn penthouse, Howard Hughes exercised an enormous influence on the presidencies of Lyndon Johnson and Richard Milhous Nixon, whom he called "our boy in the White House," manipulating American politics with a studied secrecy. Michael Drosnin hits it squarely with his remark, in his 1985 book *Citizen Hughes*, that "the great secret that Howard Hughes kept hidden was not this or that scandal, not this payoff or that shady deal, but something far more sweeping and far more frightening—the true nature of power in America."

Hughes's hidden network of political influence might never have been known to the American public had not burglars broken into Hughes's corporate headquarters, a vast warehouse on 7000 Romaine Boulevard in Los Angeles, on June 5, 1974. They found money there, and a great deal of it, but they also took something much more valuable: ten thousand pages of documents, including some three thousand in Hughes's own hand. The Federal Bureau of Investigation, despite a nationwide search, never recovered these papers. Michael Drosnin, at the time a reporter for the *Washington Post*, apparently did, through means that he has yet to make clear. His book, based on this primary evidence, spins a frightening tale of just how malignant Hughes was, and of how corrupt our politics have become.

Like many of his contemporaries in Hollywood, Hughes despised American democracy, and he freely exercised his contempt. Faced with a federal investigation into his business dealings, he wrote a memorandum to his aide, Robert Maheu, ordering him to blanket Capitol Hill with money until the problem went away. Hughes's payments were eagerly accepted, as he knew they would be, which only encouraged his contempt. He later wrote to Maheu,

> *I dont aspire to be President, but I do want political strength. . . . I mean the kind of an organization so that we could never have to worry about a jerky little thing like this anti-trust problem—not in 100 years. . . . And I mean the kind of setup that, if we wanted to, we could put Gov. Laxalt in the White House in 1972 or 76. . . . It seems to me that the very people we need have just fallen smack into our hands.*

Hughes got the people he wanted, although Nevada governor Paul Laxalt would not, as he hoped, become president, nor

bend entirely to Hughes's will. Of Lyndon Johnson, Hughes wrote, "we have a hard cash adult relationship," and Johnson, eager to match the description, awarded Hughes with an exclusive contract to supply the army with helicopters for the war in Vietnam. For his part, Richard Nixon gave Hughes any concession he asked for, fair trade for the hundreds of thousands of dollars Hughes poured into Nixon's 1972 reelection-campaign fund. (Hughes's donations were laundered and used, among other purposes, to redecorate Nixon's California home, San Clemente.) Only the Kennedy family, grown rich a generation earlier on corruption of another kind, resisted Hughes's overtures, leading him to call them "a thorn that has been relentlessly shoved into my guts."

Howard Hughes did not always have his way, even under friendly presidential administrations, but his failures were of his own making. Desiring a national forum for his right-wing political views, he once tried to take over the American Broadcasting Corporation, failing to complete the purchase only because he would not leave his cavernlike bedroom high atop a Las Vegas hotel long enough to transfer ownership of the network in the Washington offices of the Federal Communications Commission. Hughes, a television addict who stayed up around the clock to watch one B movie after another, many of them pictures he had made, had reason to want ABC: in one of his memos to Maheu, he expressed his rage that on *The Dating Game*, a popular show, a white woman had been paired with a black man for an all-expenses-paid vacation to Rome. The woman was a light-skinned black, but that was not enough to convince Hughes that the liberal media were not secret agents of miscegenation.

The Attic, first floor

Hughes was a committed racist. "Of all Hughes's phobias and obsessions," Drosnin writes, "few were more virulent than his fear and loathing of blacks." Immediately after Martin Luther King Jr. was assassinated in 1968, Governor Laxalt attempted to put into law a fair-housing act that he hoped would ease racial tension in Nevada, thereby averting the riots that had torn apart every major city in America. Enraged by what he perceived to be creeping communism, Hughes lobbied the Nevada legislature to ensure that Laxalt's bill would not pass, reasoning that blacks would leave the state if their situation were made uncomfortable enough. The bill failed, as it was almost certain to do in any event, given the state's archconservative politics and tiny minority population at the time. Laxalt left the governorship soon thereafter to move on to Washington as a United States senator.

The passage of a series of national civil-rights acts in the 1960s caused Hughes to exile himself from America in his final years, when it became apparent that even he could not buy the apartheid he wanted for his nation. He fled first to the Bahamas, then to Nicaragua, where he lived in absolute secrecy under the protection of his friend Anastasio Somoza until the great earthquake of December 23, 1972, which leveled Managua. Hughes had a profound fear of germs and illness, and he demanded that all canned food served to him be handled with surgical gloves and washed bit by bit in germ-free bowls—and this after the cans themselves had been medically sterilized. Knowing that natural disasters breed disease, Hughes instantly quit Somoza, who seven years later would be toppled by the Sandinista revolution and soon thereafter assassinated with a shot from a well-aimed bazooka in Paraguay. Hughes took up hermitage in the skies, jetting back and

forth between British Columbia, Europe, the Bahamas, and Mexico, never staying in one place long enough to attract attention. He died airborne on April 5, 1976, while traveling from Mexico City to Houston, Texas, the city of his birth. His aides, like the Chinese emperor Qin Shihuang's fearful retinue twenty-two centuries earlier, did all they could to hide the fallen ruler's death from the public.

He corrupted everyone he could reach, manipulated markets and presidencies, bought whatever and whomever he thought would serve his purposes. We have only begun to realize the extent of his activities, of Howard Hughes's sway over a nation and its rulers—and, for a time, over a windy desert city that did not make him its king but that followed him nonetheless.

Howard Hughes is gone. His name lives on only in the occasional toponym, particularly Howard Hughes Parkway, which skirts the University of Nevada and the staggeringly busy McCarran International Airport. So, too, are gone most of the members of the Rat Pack, the lounge-act lushes who popularized Las Vegas as a swingers' paradise. So, too, are gone the waters that nourished the meadows.

And in their place has risen the new Las Vegas, the American Byzantium.

♠ ♠ ♠

Cleared desert, eastern edge

Hal Rothman in his backyard

Homes for Real Families

As Real As It Gets

The future, writes Joan Didion in *Slouching Towards Bethlehem*, her fine book of essays about a New West now suddenly thirty years old, always looks good in this golden land "because no one remembers the past. Here is where the hot wind blows and the old ways do not seem relevant, the divorce rate is double the national average, and where one person in every thirty-eight lives in a trailer. Here is the last stop for all those who come from somewhere else, for all those who drifted away from the cold and the past and the old ways."

Didion needs to be updated a little: the rate of divorce and the number of Americans who live in trailers have both risen to startling heights, as has the sheer number of Americans who have drifted away from the cold Rustbelt and into the waiting arms of the sunny, amnesiac New West; the future looks so good in America because the present is so ugly. She also needs to be corrected ever so slightly, for in several fundamental respects old patterns endure. One of them is this: Las Vegas has always been about addictions, addictions to land and open sky, addictions to sex and drugs, addictions to money and chance, all the artifices of eternity. It remains so today, in a time when once-shameful addictions have become matters for public confession, even sources of pride and of much sought-after street credibility.

These addictions are all-powerful, of course. I think here of the case of a seventy-eight-year-old man who, early in 1998, opened fire on a group of gamblers, wounding five of them. The shooter tried, without success, to escape, but his dependence on a walker prevented him from putting much ground between himself and the scene of the crime. For their parts, those who were shot continued to play the slots, refusing medical treatment until ordered to receive it.

Rooster Mask, outskirts of Las Vegas

"The essential American soul is hard, isolate, stoic, and a killer," wrote the British novelist D. H. Lawrence. It is all that and more: for the essential American soul thrives in equal parts on risk and security, on the thrill of taking chances—but only with a subsidy. "Those who live in the midst of democratic fluctuations have always before their eyes the image of chance," wrote Alexis de Tocqueville. "And they end by liking all undertakings in which chance plays a part." Those undertakings, cushioned and safety-netted, have devolved into forms of amusement, the chief products of late capitalism: abstractions all, abstractions fraught with anxiety, obsession, and addiction, from Game Boy to baccarat. Just stay out of the way of the bullets.

This much is clear: the Las Vegas of Howard Hughes, all cocktails and Lycra-clad waitresses turned out to pasture, the playground of the middle class, has given way to a different Vegas, one that recognizes, in defiance of official American ideology, that, yes, there are social classes here, and that the rich are different from you and me. Let us enshrine the formal date of that split as that of the destruction of the Dunes Hotel and Casino, October 27, 1993. The last of the great Rat Pack–era, middle-class hotels, the Dunes was dynamited before a huge crowd of onlookers, a fine specimen of destruction as entertainment. Before it went the Hacienda and the Sands, once-affordable places now bulldozed into the desert.

Yes, the class war has come to Las Vegas; no longer does everyone stand equal before the croupier. On one hand is the Las Vegas of the rich, whose center is now Shadow Valley, a golf course–cum–resort Xanadu for ultramoneyed gamblers, whose members are the high-stakes premium players who wager a million dollars on a hand of blackjack or a roll at

the craps table. The management of Caesars Palace recently spent $13 million to equip just two suites for these high rollers, while at the MGM Grand Hotel a set of villas is being built for them at a cost of $700 million. Says Sandi Varvel, a public-relations executive whose job it is to market Las Vegas to the world, "With the opening of the Bellagio things went to a whole new level. When the hotel gets established it won't have a room for under two hundred dollars a night. Las Vegas used to be the home of the ninety-nine-cent shrimp cocktail and the dollar ninety-nine filet mignon, but no more. Now we've got four Wolfgang Puck restaurants. We're rivaling New York and Chicago for fine dining. It's expensive, and it's not for everyone."

On the other hand is the mass-appeal, theme-park Vegas, the Las Vegas of family fun, Bermuda-shorts- and baseball-cap-clad broods locked in an aggregate adolescence, wandering from casino to casino as if taking in a Civil War battlefield or a grand tour of Europe. Not for them the Bellagio, said to be the world's swankiest hotel; these lumpen gamblers are confined to Circus Circus and Treasure Island, on the northern end of the Strip, toward the crumbling old downtown. Every class, every subclass, now has its own casino, it seems, in the era of niche marketing. Even convenience stores and filling stations here boast slot machines, and a Las Vegas firm has just announced a line of in-home one-armed bandits for the shut-in—or perhaps, remembering Howard Hughes, the agoraphobic—market.

♠ ♠ ♠

The first Byzantium was an imperial city at the crossroads of continents, class-stratified, a city that, with its empire, grew richer, more cultured, and weaker at the same time. Its politics were an odd mix of religion, commerce, and entertainment, an oddly libertarian brew that proclaimed the need to depend on government but at the same time mistrusted politicians, and for many good reasons. Byzantium is little remembered today save as a place given to feasts, murderous politics, and icons, the stuff of art history courses and auction house catalogs.

The icons of Las Vegas are not as obvious as those of Byzantium, but they are there nonetheless, enshrined in the casino, the interior oasis of troubled souls, pew after pew of slot machines before the altar of capital; not for nothing are casinos and churches alike kept dark and innocent of clocks, resulting in both spaciousness and timelessness, in a grand symbolic grammar.

Consider, for instance, the grandfather of the spectacle casinos, the appropriately named Caesars Palace, built largely with financing from the Jimmy Hoffa–era, ill-fated Teamsters Union Central States Pension Fund. The casino's builder and first owner, Jay Sarno, believed that the oval was the most restful of shapes, and perhaps the one thus most likely to relax the owners of wallets and purses enough to coax money from them. (He may have been right: several owners later, Caesars Palace remains one of the most consistently profitable casinos in Las Vegas.) Sarno therefore ordered that construction of the casino follow elaborate, egg-shaped patterns that can be only dimly discerned today, now that a Planet Hollywood and a shopping mall have been tacked on to the original structure. The egg, the world egg—a shape favored

The Attic, second floor, camera self-portrait

by Byzantine architects, too, who would have reveled in the splendor of Caesars Palace, with its eighteen fountains, its tons and tons of imported Mediterranean marble, its ersatz Nike of Samothrace (overlooking, quite by accident, a Nike shoe store), all imparting authenticity to artifice. Those ancient architects would have also liked the MGM Grand Hotel, at this writing the largest in the world, and the architectural gigantism, and the endless trompe l'oeil adornment by which every improvement, every renovation, calls for a retaliatory spruce-up on the part of any neighboring building. Thus, whereas the newish Excalibur looks at this very moment a little run-down next to the fabulous and furious construction taking place at the nearby Luxor, it will almost certainly soon wear a new suit of armor, in homage to the doctrines of planned obsolescence and the short shelf-life of commodities in a world gone mad for them.

Las Vegas, city of icons, once considered to be a mere "spectacle suburb" of Los Angeles, has far surpassed the excesses of Disneyland and the junkier side of Hollywood. Edmund Wilson was right in his time to call Los Angeles the "great anti-cultural amusement-producing center" of America. Las Vegas is today just as vital as a center in the making of all our empty entertainments; were the film industry to be moved there, as "white flight" from Los Angeles may one day have it, Las Vegas would be the world's first utterly virtual metropolis.

Yet Las Vegas is far more than that. It is also a world city, the easternmost outpost of the Pacific Rim, a direct destination for airline flights from faraway continents. Now, in some Las Vegas restaurants the addition of hoisin sauce to a hamburger constitutes Pacific Rim cuisine, but the city's emerging connection to Asia goes much further. China, where capitalism is

Holiday Inn, Las Vegas Boulevard

Sidewalk outside The Venetian

St. Mark's Square, The Venetian

The Forum Shops at Caesars I

The Forum Shops at Caesars II

Paris, Las Vegas, interior | Paris, Las Vegas, the Eiffel Tower from the pool (opposite)

Bugsy Siegel, Madame Tussaud's Las Vegas

Bugsy Siegel Memorial, The Flamingo

being rebuilt anew on the other side of the Pacific Rim, is Las Vegas's mirror in many ways. There corruption on the Hughesean scale has always been the rule, a corruption given new vigor in the booming economy; as one Communist Party member said to me, "The government has fun. They drink. They smoke. They go with girls. But they don't want the people to do this. Then they lose control of the people." And, said another party member, looking at the well-dressed young people on Shanghai's Nanjing Road, "In the seventies we had blue Mao suits. In the eighties we had business suits. In the nineties we have T-shirts."

He was right; T-shirts, the uniform of neoliberalism and Pax Coca-Cola, are everywhere, as ubiquitous on Nanjing Road as on Las Vegas Boulevard. But China is changing in more than just fashion. In a generation the standard of living has improved dramatically in almost every sector of society. There has been an immense reduction in poverty throughout the country. In the wake of the one-child revolution, me-first consumerism is rising, and, for the first time ever, there is plenty to consume, albeit at fearful cost to the environment. China's growth is astonishing: its economy is projected to surpass that of the United States and to become the world's largest by no later than 2020. Within the country, signs of this growth are everywhere. Old wood-and-brick neighborhoods in Beijing are being bulldozed away in the name of progress, displacing hundreds and thousands of people. One such neighborhood, not far from Tiananmen Square, is now being remade into a twenty-four-story megaplaza with shopping malls, health clubs, luxury condominiums, and four-star hotels.

In short, Beijing is becoming Las Vegas without casinos, another capital of twenty-first-century capitalism. And the

casinos are not even necessary; when Beijing remakes the Forbidden City into a historical theme park, when the masses have open access to the demimonde of girls and alcohol and hitherto forbidden entertainments, the transformation of the western edge of the Pacific Rim into a twin of the easternmost outpost will be as good as complete.

Las Vegas, crossroads of continents. Lenadams Dorris, a native who owns a hip little coffeehouse not far from the old downtown, is a rarity, an unapologetic admirer of all that the city is and hopes to be. He puts it just right: "Las Vegas is not really a city of the United States, but a city of the world," he says. "We have a zone of activity that is transnational; it is really irrelevant to us what our neighboring cities are doing. There was a terrible period in the late 1980s and early 1990s where Las Vegas was trying to paint itself as just another town, which is absurd. We're not just another town; we are the most spectacularly odd urban thing ever to happen on this planet. Let's revel in it, and if you can't revel in it, just shut up and let it revel in itself. We don't need to prove to the world that we are valid. They prove it to us every day, with their dollars." Not content to stop with that, Dorris even pictures a future Vegas as an emergent city-state along the Renaissance ideal, finally declaring its independence from the Nevada outback that it supports and allying itself with other such city-states and neocapitalist formations: the People's Republic of Santa Monica, perhaps, or, as in one of my fond dreams, the Holy Sonoran Empire.

Dorris celebrates the "real" Las Vegas, one that inarguably exists but is out of view of casual visitors, a Las Vegas of neatly clipped lawns and low crime rates, the Las Vegas of individual taxpayers and fast-food eateries. That Las Vegas is

largely inaccessible to outsiders, to tourists who would not be much interested in it anyway. Certainly it is not promoted by the advertisers who tout the Mirage, the Bellagio, Circus Circus. A dead zone of decayed, abandoned buildings cordons off the vibrant Strip from the rest of the city, and few tourists venture beyond it. Beyond that dead zone of homeless shelters, blood banks, and rubble, beyond the Las Vegas equivalent of Byzantium's city wall, lies a different city entirely, one that stretches to the horizon, made up of a congeries of strip malls and walled suburbs. This Las Vegas illustrates an observation by the Indian economist Deepak Lal:

In many ways, at the frontiers of the West ... there is a return to the Middle Ages, as "decent" citizens, irrespective of race, increasingly live (or want to live) in gated communities or distant suburbs from which they commute to privately policed workplaces. The only danger lies in the public places they have to traverse in getting from home to work. These are infested with the modern versions of medieval highwaymen—muggers and carjackers. This growing failure of Western states to provide the most basic of public goods—guaranteeing their citizens' safety—is eroding their legitimacy, but it need not dissipate the economic vigor of the West.... This failure, however, will make the West a dangerous place in which to live.

A return to the Middle Ages, to Byzantium; those walled communities are a collection of city-states, republics of like-minded normality. Like Los Angeles, Las Vegas is growing, and to huge proportions. Even so, this world city is no city at all, no place with a real center; Las Vegans go to the Strip only to work. In place of any "real" Las Vegas, we have another reality altogether, that of the MGM Grand golden lion and a rising replica of the Eiffel Tower, that of carefully manufactured show.

"Evolution in Las Vegas is consistently toward more and bigger symbolism," write the architects Robert Venturi, Denise Scott Brown, and Steven Izenour in their now-classic 1977 study *Learning from Las Vegas*. "The Golden Nugget casino on Fremont Street was an orthodox decorated shed with big signs in the 1950s—essentially Main Street commercial, ugly and ordinary. However, by the 1960s it was all sign; there was hardly any building visible." Venturi and his colleagues, like Joan Didion, need to be updated, for Las Vegas is grown up now. The signs are smaller, the buildings more than those glorified sheds; instead, they are remarkably playful works of consumer art, icons with their own homegrown symbology. One has only to see the exceedingly odd New York, New York or the Luxor, which is becoming ever more plainly a monument of its own magnificence, to appreciate this point.

Las Vegas symbolism, always a national curiosity, is becoming an altogether strange thing, an artifact of self-reference: it encompasses the entire history of the planet, drawing on all times and places, the product of a global scavenger hunt, a bricolage of incredible proportions, a paragon of what the architectural critic Reyner Banham called the "fantasticating tendency" of the Far West. That play of mixed histories produces strangely mixed results. Las Vegas is in many critical respects an utterly forward-looking city, but even if its current big-selling show is Mystère, a Cirque du Soleil piece that introduces conceptual and performance art to a mass audience, elsewhere it thrives on nostalgia; on a night early in 1998, the headline acts advertised on the Strip were Tom Jones, Mary Wells, David Cassidy, and George Carlin, time-warped in from the late 1960s.

Mark Zartarian, culinary union organizer and photographer

Keith and Karen Smith and family (day after moving to Las Vegas)

House of the Lord I

House of the Lord II (Mormon Temple)

Organized Living: Get Into It!

No Exit

Live the Life, Love the Price

The Bomb

But so be it. Las Vegas is the world in miniature, a global Wunderkammer, encompassing Assyria and Manhattan, the Valley of Kings and the Valley of the Dolls, with all times, all cultures, all locations carted in as casino magnate Steve Wynn and his peers roam the world like modern-day Lord Elgins, transporting the ages to the new Byzantium, a city visible from far out in space, full of pretty loot—a city, Wynn once remarked, that God might have made "if He'd had the money."

Call it Worldland.

One of the stranger new entries in that theme park is Red Square, a restaurant inside the massive Mandalay Bay casino, at whose entrance stands a giant, headless statue of Vladimir Lenin. The interior is an amalgam of loot from the fallen nations of the Communist world: the central gold-and-crystal chandelier, for instance, is one of two taken from the Polish embassy in Moscow (at this writing, the singer Michael Jackson owns the other one), and the proletarian art—mostly giant blood-red workers-of-the-world posters—decorating the restaurant's walls was scavenged from government flea markets throughout the former Soviet Union.

Red Square's interior has met with no objections, but the Lenin statue—manufactured in the United States, and originally with a massive head—did rile a few locals. "Some people were upset by it," says Sandi Varvel. "I guess they didn't understand that we won the Cold War. They probably don't understand the redistribution of wealth that goes on in the casinos, either."

Under the orders of Mandalay Bay's management, a team of welders swept down on Red Square in the middle of the

night. When they were finished, the statue was without its fake pigeon dung-bespattered head, which disappeared for a few weeks. "It turned up in a Las Vegas thrift shop," says Varvel, "and Red Square bought it back. They're going to encase it in ice and use it as a table in their vodka freezer."

A dangerous place, Las Vegas: dangerous for statues, dangerous for the ghosts of a failed past.

♠ ♠ ♠

History repeats itself, said Karl Marx: first it comes as tragedy, then it replays as farce. A drive down the Las Vegas Strip reveals as much. We are replaying, everywhere in Western culture, the nineteenth-century tragedy of speculation, degradation, and accumulation, but now with very little in the way of actual production—which makes Las Vegas the model postindustrial center, the capital of the twenty-first century.

At the dawn of that new millennium, the world will be Las Vegas's: Howard Hughes's vision, enlarged, of a world in which politics, industry, and entertainment are one and the same. That world is already here, writes the Dutch scholar Wim Brockmans in his superb *History of Power in Europe*,

The Berlin Wall, Main Street Station

Headless Lenin, Red Square, Mandalay Bay 1

Bar, Red Square, Mandalay Bay II | Lenin's Head in the vodka locker, Red Square, Mandalay Bay III (opposite)

It is not the politicians who can now be considered the most effective interpreters of values and norms but the hidden persuaders of capitalism who in the form of entertainment play on the aesthetic and emotional dimensions of the public. In this they have reached a degree of technical perfection which makes the propaganda campaigns of preachers in the thirteenth century, Jesuits in the seventeenth, nationalists in 1900, and bolshevists and nazis look paltry. What, then, is their message? Materialism, individualism, and competition, the core values of capitalism. Other values such as democracy, the rights of man and pacifism are put second by the capitalist entrepreneur and in practice desecrated daily whenever that improves his profit.

Brockmans is right. The world is turning ever more to entertainment as a way of fending off reality, learning the core values of capitalism in the process and paying for the privilege. And as it does, Las Vegas, or something very much like it, will be replicated around the planet in satellite cities in places like, well, China. This is not so far-fetched, for the twenty-first-century economy is likely to involve mass entertainment and games of chance on a scale without twentieth-century precedent. As a University of Nevada, Las Vegas, economist said recently, "I can't think of anything that gives as much hope for general social development, employment, economic development, health, and education as gaming operations." He was speaking of America's Indian reservations, but the rest of the Third World—and the Second, and the First—is fair game, too.

The world as casino: welcome to the millennium.

For now, there is but one Las Vegas: it is real, it is alone, and it is spectacular. And in this aoristic city, the only real curiosities are the unbelievers and the documentarians, the filmmakers with their obligatory casino-lights-on-a-polished-car-hood cautionary tales, the doubting journalists. Swallow fire on Las Vegas Boulevard and you will be passed by; produce a notebook or a camera and you will draw onlookers outside a casino, security guards within—for Hunter Thompson's "don't burn the locals" rule, so often violated throughout the narrative of his *Fear and Loathing in Las Vegas*, now carries the afterword, "as long as it doesn't threaten the bottom line," which cameras and notebooks surely can do.

I think in this instance of a cold February night when Virgil Hancock and I went out to behold—and that is the word—the newly installed golden lion at the MGM Grand Hotel, an imperial symbol overlooking the city's largest intersection. Buffeted by an aggressively icy wind, we set to work: Virgil began making images with his impossible-to-conceal 8 by 10 camera, while I retreated to a corner and began taking notes on the passing scene. A tourist approached to ask what I was writing about. You, I replied.

I was not being supercilious. There, in the center of the world city, I was writing about him, and about the countless other tourists who stood gazing at the fabulous sights of the Strip, and about all of us at the dawn of the millennium.

♠ ♠ ♠

Slots for Your Home

Blue Angel Motel

Angel's Furniture

Totally Nude Review

Memories

Pet cemetery

Your future starts here. So reads a billboard in the center of Las Vegas, proclaiming the world city's message to its waiting empire. Your future starts here, here in the place of wind-eroded blue angels and boarded-up shops, here in a city that promises all manner of instant gratification and rewards believers with anxiety and loss.

Yes, the sign says, "Your future starts here." But it is worth remarking in the face of such optimism, as the poet Wallace Stevens did, that "Incessant new beginnings lead to sterility." For all its flash and glitter, for all its comfortable new developments stretching off to the horizon, for all its obvious wealth, Las Vegas is a sterile place, a world city of pastiche and pose, its very culture a commodity. In the end, this new American Byzantium resembles nothing so much as a wax museum, carefully arranged but essentially lifeless.

Other signs tell other stories of Las Vegas, "Of what is past, or passing, or to come," to use the words of William Butler Yeats, that chronicler of the first Byzantium. "Drugs and prostitution prohibited." "300,000 couples happily married here." "You're a guaranteed winner." "Instant cash." "Homes for real families." "Where winners belong." "Cash a check here and get free Pepsi." "Totally nude review." "Live the life. Love the price." "Organized living. Get into it." "Global power for America." "Elvis slept here." "As real as it gets."

And, of course, "No exit."

On the Strip, in the dead center, in the far-flung boomburbs, the rise and fall of Western civilization is recapitulated daily, and tragedy and farce freely combine.

Your Future Starts Here

As real as it gets, indeed.

Addiction, accumulation, sociopathy, dissimulation: Las Vegas, a placeless place that trades on artful abstractions and hollow promises. All that is solid melts into air: here and everywhere it becomes harder and harder to break through the facades of the Potemkin villages in which we live to see what lies behind them.

Yet behind Las Vegas lie the enduring constants of this place: sun, water, and the wind that will one day erase any sign that we walked this ground.

The future starts with them, and it starts here. ♠

Chief Hotel Court and Fremont Street Experience

Celebrity Centre

Movie Celebrities, Madame Tussaud's Las Vegas

Sports Tableau, Madame Tussaud's Las Vegas

Ruben and Delilah Maldonado in front of their favorite spot, Somerlin

Nosferatu, Museum of Magic and Movies | *Guzzler,* Guinness Book of World Records *(opposite)*

RAW EGGS EATING
On May 16 1984 in Kilmarnock, Ayrshire, Scotland, Peter Dowdeswell added to his long line of eating feats by consuming 13 raw eggs in 1 second.

CHICKEN
Sean Barry ate 3 lb 12 ozs (1.7 kg) of chicken in 8 minutes 5 seconds at Cheltenham, Gloucestershire, England July 5 1986.

HARD-BOILED EGGS
John Kenmuir of Scotland consumed 14 hard-boiled eggs in 14.4 seconds on April 17, 1987.

SNAIL EATING
André Bustarrichs of Víllagarcía consumed 1.1 kg (38.8 oz) of snails flavoured with Biscay in sauce in 1 minute 5.6 seconds of Karle café, Vizcaya, Spain on 27 April 1986.

ELVERS (YOUNG EELS)
Peter Dowdeswell of Northampton, England ate 1 lb (453 g) of young eels (elvers) in 13.7 seconds on October 20, 1978.

PICKLED ONIONS
Pat Donahue ate 91 pickled onions (30 ozs, 850 g) in 1 minute 8 seconds in Victoria, British Columbia, Canada, March 9, 1978.

Tableau, Museum of Magic and Movies (opposite) | Classroom for Dummies, Museum of Magic and Movies

Desert, southwestern edge

Global Power for America | *The Strip rises out of the desert (following spread)*

AMERICAN BYZANTIUM

AMERICAN BYZANTIUM

CREDITS

I want to thank the following people and companies for allowing their photographs to be published in this book:
- Valentine Vox and the participants of the Ventriloquist Convention, 1999
- Keith and Karen Smith
- Ruben and Delilah Maldonado
- Hal Rothman
- Mark Zartarian
- Star Trek Experience and Viacom Consumer Products
- The Venetian
- Aladdin Resort and Casino
- Paris, Las Vegas
- Circus, Circus
- The Forum Shops at Caesars
- Madame Tussaud's, Las Vegas
- Red Square and The Rum Jungle
- ™ The Estate of Marilyn Monroe licensed by CMG Worldwide Inc., Indpls., IN www.MarilynMonroe.com
- The Luxor
- The Guinness Book of World Records
- Desert Passage
- The Attic
- Main Stre'et Station

ACKNOWLEDGMENTS

I wish to express a special thanks to the following people and non-profit institutions: Joseph Wilder of the Southwest Center, University of Arizona for his continued friendship and support; David Holtby, my editor, and Robyn Mundy, the designer, at the University of New Mexico Press for their wonderful suggestions and guidance; Greg McNamee for his excellent text; Valentine Vox for his creativity and Hal Rothman for a number of great conversations and drinks at the Red Square. And the three people in my life who provide the reasons and the love: Andrew, Nathan, and Judith. This book is dedicated to them.

Virgil Hancock III

A University of Arizona Southwest Center Book
Joseph C. Wilder, Series Editor

© 2001 by Virgil Hancock III
All rights reserved.
First Edition

Library of Congress Cataloging-in-Publication Data

Hancock, Virgil, 1953–
American byzantium : photographs of Las Vegas / by Virgil Hancock III;
with an essay by Gregory McNamee.
p. cm.—(University of Arizona Southwest Center book)
ISBN 0-8263-2350-2
1. Las Vegas (Nev.)—Pictorial works. 2. Las Vegas (Nev.)—Description
and travel. 3. Performing arts—Nevada—Las Vegas—Pictorial works.
4. Performing arts—Social aspects—Nevada—Las Vegas. 5. Performing
arts—Economic aspects—Nevada—Las Vegas. I. McNamee, Gregory.
II. Title. III. Series.
F849.L35 H36 2001
979.3'135—dc21
2001001168

Color Separations by Sung In Printing Korea, Ltd.
Printed and bound by Sung In Printing Korea, Ltd.
Text set in Gill Sans Light with Goudy Sans Italic
Display text set in Trajan with Goudy Sans Medium
Book design and composition by Robyn Mundy

DUE

Brodart Co. Cat. # 55 137 001 Printed in USA

TUFTS UNIVERSITY LIBRARIES
3 9090 01745 9609